POSTCARD HISTORY SERIES

# *The Upper West Side*

## CYRUS CLARK

Cyrus Clark (1830–1909) was known as the "Father of the West Side." A silk trader turned real estate investor, he took up residence on the West Side in 1870, building one of Riverside Drive's most notable mansions (page 119). As president of the West End Association for 15 years, he championed the development of Riverside Drive and Park, promoted sanitary and street improvements, and pushed for an underground rapid transit system. After his death, a plaque was commissioned in his honor from the noted sculptor Henry Kirk Bush-Brown that still resides on a rocky outcropping within the West 83rd Street entrance to Riverside Park.

*On the front cover*: Please see page 11. (Author's collection.)

*On the back cover*: Please see page 23. (Author's collection.)

POSTCARD HISTORY SERIES

# *The Upper West Side*

*Michael V. Susi*

ARCADIA
PUBLISHING

Copyright © 2009 by Michael V. Susi
ISBN 978-0-7385-6316-9

Published by Arcadia Publishing
Charleston, South Carolina

Printed in the United States of America

Library of Congress Catalog Card Number: 2008903416

For all general information contact Arcadia Publishing at:
Telephone 843-853-2070
Fax 843-853-0044
E-mail sales@arcadiapublishing.com
For customer service and orders:
Toll-Free 1-888-313-2665

Visit us on the Internet at www.arcadiapublishing.com

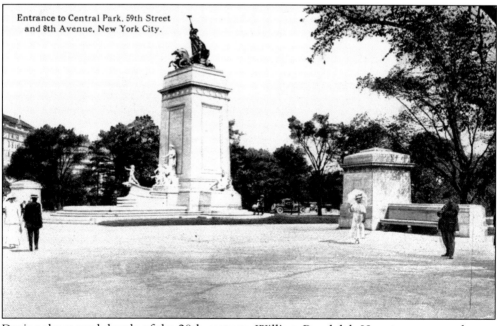

Entrance to Central Park. 59th Street and 8th Avenue, New York City.

During the second decade of the 20th century, William Randolph Hearst, newspaper baron, bought several properties on Columbus Circle in an attempt to turn it into "Hearst Plaza," an ill-fated venture that included the construction of the two-story American Circle Building (see page 13). His only lasting addition to the circle, at the entrance to Central Park, is the National Maine Monument, completed in 1913 and commemorating the destruction of the battleship *Maine* in 1898.

# CONTENTS

Acknowledgments                                          6

Introduction                                             7

1.   Columbus Circle to Lincoln Square                  11

2.   Central Park West                                   27

3.   Broadway                                            45

4.   Columbus Avenue                                     77

5.   Amsterdam Avenue                                    87

6.   West End Avenue                                     95

7.   Riverside Drive                                    107

Bibliography                                            127

# ACKNOWLEDGMENTS

Preparing this book, my second in Arcadia Publishing's Postcard History Series, could not have been possible without the continuing support of my partner Sean Sawyer and good friend Joseph Ditta, soon to be a published Arcadia Publishing author himself. Their encouragement and research support were invaluable, as were the three cards lent from Joe's personal collection of New York Historical Society ephemera.

Bob Stonehill, my fellow postcard collector, has lent an astonishing 35 cards to this book out of his vast collection of Upper West Side postcards and real-photo postcards. The rarity and high quality of these cards cannot be overestimated, nor can Bob's willingness to participate in the projects that mean a great deal to me. All of the remaining postcard images and photographs are from my collection.

I also wish to thank my favorite Upper West Siders who have made the neighborhood a second home to me for almost 30 years (starting from Columbus Circle and proceeding northward): Elizabeth Beautyman, M.D., Jack Binder, D.D.S., Amy Brauner, Kathe Davridge, Bernard Green, the folks at Café 82 and the Barnes and Noble Booksellers at 82nd Street, and most significantly, Mary Beth Kelly, A.C.S.W.

I could not end my acknowledgements without recognizing the person who defines the Upper West Side to me, in all its various shadings—good, bad, and indifferent. Strike that, *never* indifferent! She has lived through the West Side's drastic fall in the 1960s and 1970s and its dramatic rise once again in the last two decades. Even though she defects to the East Side occasionally, her heart lies squarely on Columbus Avenue and West 75th Street, where her father sold flowers in his James Flower Shop after having emigrated from Greece in 1928 and where she has always lived.

This book is dedicated to my dear friend of many years Evangelia Nonis.

# INTRODUCTION

Everything indicates that this favored district, bordered on the one hand by Central Park and on the other by the magnificent scenery of the Hudson River, and bisected throughout by the Grand Boulevard, is the chosen ground of the future fashion and wealth of New-York. The Ninth Avenue must, from necessity, become the business avenue of that district, since the Eighth (soon to have a more aristocratic name) and the Boulevard will be appropriated by magnificent residences and ornamented grounds . . . There is no rule to measure the value of property in New-York when touched by the golden wand of fashion. She wills it, and costs disappear from the calculation. Some men's fortune is in their foresight. Such are laying their fortunes now, in the West Side district.

This excerpt, from "The West Side," printed in the *New York Times*, was occasioned by the sale of property from Eighth to Ninth Avenues and from West 71st to West 72nd Streets in February 1869. Certainly the "golden wand of fashion" had found the rustic village of Bloomingdale on the west side of Manhattan in the waning years of the 19th century, thereby turning it into the West End by 1900.

The West End encompassed the area from the Grand Circle at West 59th Street (renamed Columbus Circle) northward between the Hudson River and Central Park to an ill-defined northern border somewhere below Manhattanville at West 125th Street (see the map on page 10). During the 1890s, the numbered avenues of the West End acquired their current names above West 59th Street; Eighth Avenue became Central Park West, Ninth Avenue became Columbus Avenue, Tenth Avenue became Amsterdam Avenue, the Grand Boulevard was rechristened Broadway, and Eleventh Avenue was renamed West End Avenue. Riverside Drive, along the Hudson River, was briefly Riverside Avenue.

In the early 20th century, the golden wand was waved again as the West End became the Upper West Side, and the early West Siders watched as new waves of construction transformed the seemingly solid streetscapes of the late 19th century. Maybe it was progress and modernity that helped elicit the change to Upper West Side, or maybe it was just that the appellation West End was too pretentious for the kind of people who lived there.

There was much hope and hype in the 1870s and 1880s that the West End would surpass Fifth Avenue in attracting the well-to-do to the area's avenues and boulevards. Riverside Drive, originally designed in 1873 by Frederick Law Olmstead, was an integral part of his Riverside Park scheme to tame the hillsides leading down to the Hudson River all along the West End. A winding boulevard with vistas stretching for miles up and down the river, it was to become home to some of the finest private residences in the city. However, the aristocratic New Yorkers did not budge from their mansions on the East Side.

The fresh air and unspoiled riverfront were not enough to lure the blue bloods from their established lifestyles on Fifth Avenue; maybe it was the hotels, nightclubs, theaters, and cabarets (with their attendant crime and vice) at Columbus Circle, gateway to the West End, that helped deter them. On the other hand, the sense of adventure and liberation in the fledgling neighborhood did attract a vital source of energy to the West End, young married couples with families who were willing to take a chance and join the early pioneers in the neighborhood. Pioneers like the developer Edward S. Clark, who built the Dakota and a multitude of fine town houses in the 1870s, and neighborhood activist Cyrus Clark, president of the West End Association. The numerous clubs and fraternal organizations, churches, and charitable organizations also contributed to the tremendous growth of the West End in the late 19th century. But none of these determined the unique character of the neighborhood more than its architecture and its avenues.

The Dakota was built on Eighth Avenue (Central Park West) from 1882 to 1884 and set the standard high for Central Park West as a boulevard of extravagant hotels and apartment-hotels, such as the Hotel Majestic, Hotel San Remo, and Hotel Beresford. These were joined by several impressive churches, with First Church of Christ Scientist and the Church of the Divine Paternity among them. By the early 20th century, the American Museum of Natural History had its home here, and the New York Historical Society would soon move here. In the 1920s and 1930s, a final wave of development solidified the apartment house, several with signature towers, as the dominant building type on the avenue.

Columbus Avenue, in the shadow of the Ninth Avenue Elevated, was the commercial street where everything, from groceries and fruits to eyeglasses, was available on the ground floors of tenements, middle-class apartment houses, and hotels with names such as La Rochelle and Endicott. Amsterdam Avenue likewise was the site of many a tenement, but unburdened by the elevated structure, it attracted many churches and charitable institutions. Park Presbyterian, Church of the Holy Name of Jesus, St. Michael's, and West End Presbyterian all still grace this thoroughfare.

West End Avenue, originally envisioned as a retail street with businesses catering to the needs of the Riverside Drive elite, developed instead into a boulevard of high-class town houses, small apartment houses, churches, and schools. In the early decades of the 20th century, much of the housing stock was demolished for vast canyons of elegant apartment houses. The high expectations for the Grand Boulevard, or Broadway, were not quite realized until the coming of the Interborough Rapid Transit (IRT) subway in 1904. Before this time, theaters, nightclubs, and popular hotels lined Broadway from Columbus Circle to Lincoln Square. With the advent of the subway, elegant apartment houses, larger than any previously built in New York, were constructed, the Ansonia, the Apthorp, and the Belnord, among them.

Collected here are almost 200 postcard images of the Upper West Side from the beginning of the 20th century to the 1920s. They include "printed" postcards, mass-produced from photographs, as well as "real-photo" postcards, produced in limited quantities from negatives on photographic paper. Supplementing these are several cameo portraits from *King's Notable New Yorkers 1896–1899*, a compendium of famous men from all professions. The first chapter begins at Columbus Circle and proceeds north to Lincoln Square; after that, each avenue is given its own chapter, in order of its proximity to Columbus Circle. In the captions, parentheses generally denote the year of completion of a building and the name(s) of the architect(s) responsible for the design. I have used West 106th Street as the neighborhood's northern border; those wishing to explore further north, I refer to my earlier book in this series, *Columbia University and Morningside Heights*.

As you peruse the images and read the captions, I encourage you to take this book with you and walk the avenues and side streets of the Upper West Side. And if you find you are interested in reading more about its history and architecture, the bibliography at the end of the book is a good place to start. Enjoy.

—Michael V. Susi

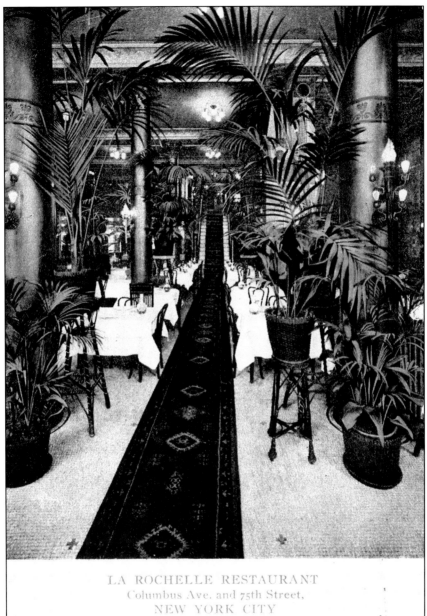

LA ROCHELLE RESTAURANT
Columbus Ave. and 75th Street,
NEW YORK CITY
This magnificent restaurant is now under new management. Cuisine
ervice of the best. Special attention paid to Theatre Parties. Music fur
ished by a famous orchestra.

Messrs. Mebler & O'Donnell, Props.

The Platinachrome Co. N.Y.

The epitome of elegance and sophistication on Columbus Avenue and West 75th Street was the restaurant La Rochelle, which filled a cavernous double-height space in an apartment house of the same name (page 80). Advertised as the "coolest dining room" in town, its theatrical appearance, famous Hungarian orchestra, and red carpet treatment entertained the smart theater crowd of the early 20th century.

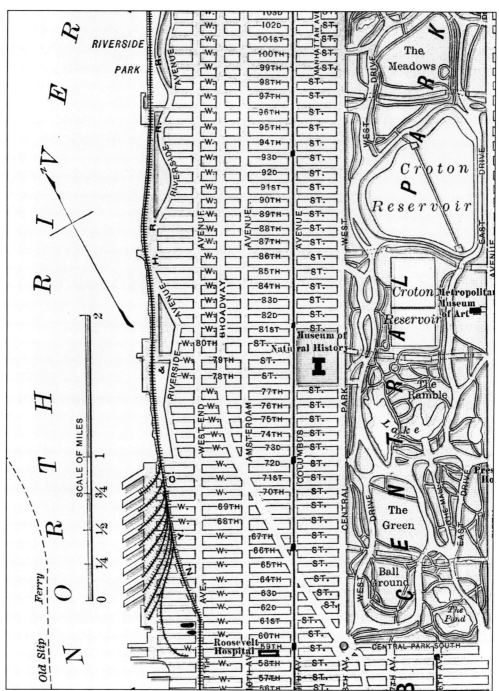

This is a map of the Upper West Side from 1900. The street grid already established and the avenues now sporting their fashionable new names, all that was left was for the subway to arrive and development, and in many cases redevelopment, would flourish to a degree not seen before. Note the exposed railroad tracks along Riverside Park, the piers that ran along the North (Hudson) River from West 63rd to West 71st Streets, and the stations of the Ninth Avenue Elevated along Columbus Avenue.

# *One*

# COLUMBUS CIRCLE TO LINCOLN SQUARE

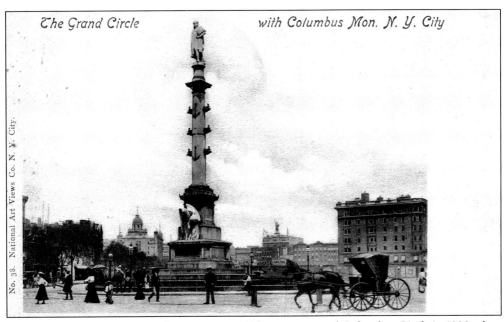

The Grand Circle, gateway to the Upper West Side, was renamed Columbus Circle in 1892 when Gaetano Russo's sculpture of the great navigator and his angel of discovery was begun, 400 years after Christopher Columbus sailed to America. In this 1904 view, one can see to the column's north the first Hotel Empire (1894, page 20) and the Liberty Storage Warehouse, with its 30-foot replica of the Statue of Liberty, now in the sculpture garden at the Brooklyn Museum.

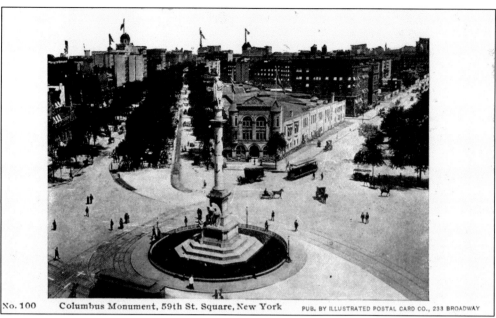

No. 100    Columbus Monument, 59th St. Square, New York    PUB. BY ILLUSTRATED POSTAL CARD CO., 233 BROADWAY

Columbus Circle, seen here in 1899, is located near the southwestern corner of Central Park where West 59th Street meets the crossover of Central Park West (the extension of Eighth Avenue) and the newly named Broadway. Still a grand tree-lined boulevard at the time, it would soon be the site of a major engineering feat, the construction of the Interborough Rapid Transit (IRT) subway. Durland's Riding Academy (1887) occupies the building behind the monument.

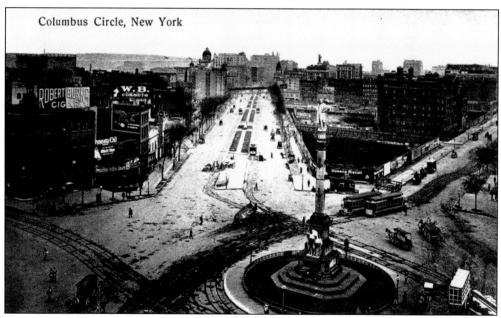

Columbus Circle, New York

Durland's Riding Academy moved to West 66th Street between Central Park West and Columbus Avenue in 1901, leaving a vacant building that burned to the ground only a year later. This view from early 1904, before the subway exit kiosks were constructed, shows Broadway after cut-and-cover construction extended the city's first subway line here.

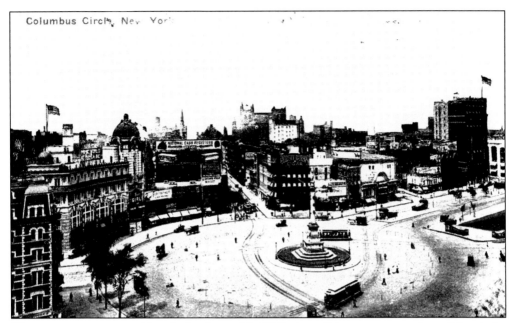

Theaters, restaurants, and hotels dominate this 1908 view of the western portion of the circle, with West 59th Street bisecting the view. The Pabst Brewing Company built the Grand Circle Café and Roof Garden and the Majestic Theatre (curved facade) in 1903. In the distance is the Church of St. Paul the Apostle on Columbus Avenue and West 60th Street.

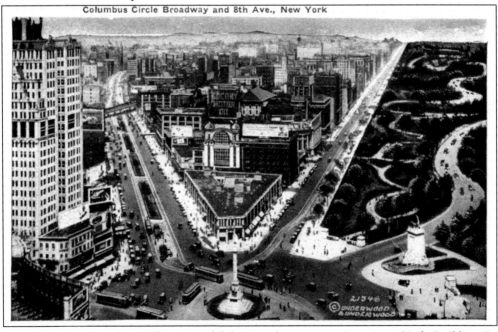

By 1921, it was clear that William Randolph Hearst's two-story American Circle Building (in the center of this view) was not going to achieve its planned 30 stories and become the first skyscraper on Columbus Circle. This honor went to the Gotham National Bank Building (1921) on the left, which was replaced in 1956 by the New York Coliseum and then again in 2004 by Time-Warner Center.

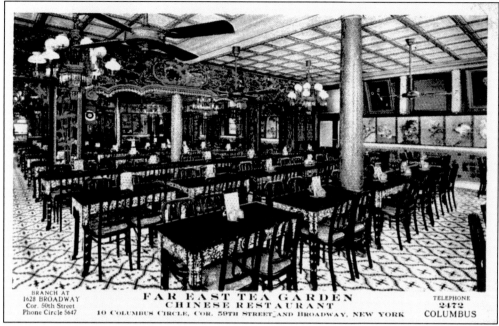

Among the myriad restaurants catering to the exotic tastes of revelers who came to be entertained at the nightclubs, cabarets, and theaters in Columbus Circle was the Far East Restaurant and Tea Garden at Broadway and West 59th Street. They advertised "Good Chinese Food" while imploring doubters "You are invited to inspect our kitchens."

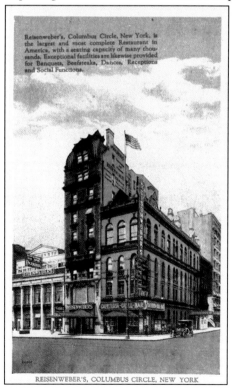

REISENWEBER'S, COLUMBUS CIRCLE, NEW YORK

Reisenweber's was a lobster palace extraordinaire in three adjoining buildings on the northwest corner of Eighth Avenue and West 58th Street (now the Steelcase building). It boasted a seating capacity of many thousands, dancing in the afternoons, and the city's first floor show. Patrons, who included Diamond Jim Brady, Sophie Tucker, Al Jolson, and Enrico Caruso, ranked it as the city's favorite nightspot in the years leading up to Prohibition. (Collection of Bob Stonehill.)

14

In addition to cabaret, there was entertainment provided by world-renowned musicians such as the Royal Poinciana Quintette (spelled incorrectly on the advertisement shown here) and New Orleans jazz from the Original Dixieland Jass Band featuring Nick LaRocca on the cornet. (Collection of Bob Stonehill.)

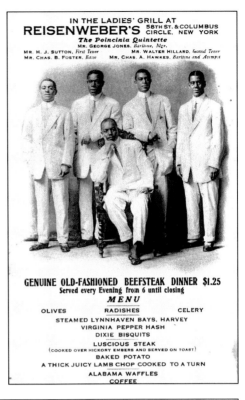

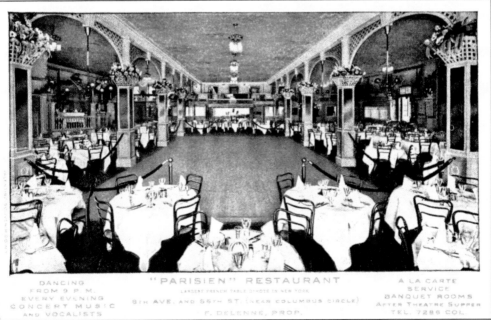

This view from 1915 shows the dance floor of the Parisien Restaurant on Eighth Avenue and West 56th Street. Billed as the "Largest French Table D'Hote in New York" there was music and vocalists every evening, along with the best patrons the West End and Fifth Avenue could provide. During Prohibition, the Parisien regularly made the newspapers after several infamous raids.

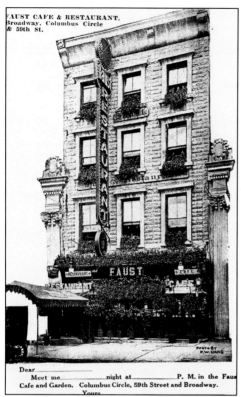

FAUST CAFE & RESTAURANT, Broadway, Columbus Circle & 59th St.

Dear_____
Meet me_____night at_____P. M. in the Faus
Cafe and Garden. Columbus Circle, 59th Street and Broadway.
Yours

Further up on Columbus Circle at Broadway between West 59th and West 60th Streets was the Faust Café and Restaurant. Like Pabst's Grand Circle, the Faust was a glorified beer hall. A latecomer to the circle in 1910, it did not take long for notoriety to come to Faust. A gambling raid shortly after its opening yielded a roulette wheel, poker chips, dice, several decks of cards, and some very welcome publicity.

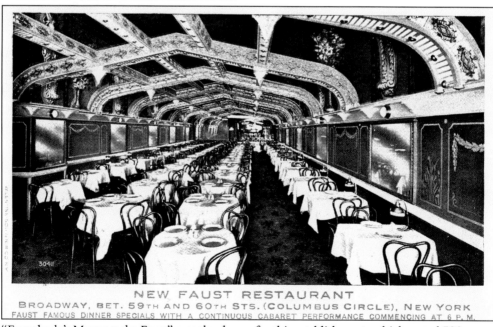

NEW FAUST RESTAURANT
BROADWAY, BET. 59TH AND 60TH STS. (COLUMBUS CIRCLE), NEW YORK
FAUST FAMOUS DINNER SPECIALS WITH A CONTINUOUS CABARET PERFORMANCE COMMENCING AT 6 P. M.

"Everybody's Merry at the Faust" was the slogan for this establishment, which seated 500 every night on four floors with entertainment provided by comedians, singers, and a famous 12-piece banjo orchestra. Regardless of these attempts at merrymaking, and a 40-year run in St. Louis before opening in New York, bankruptcy proceedings began in 1915.

16

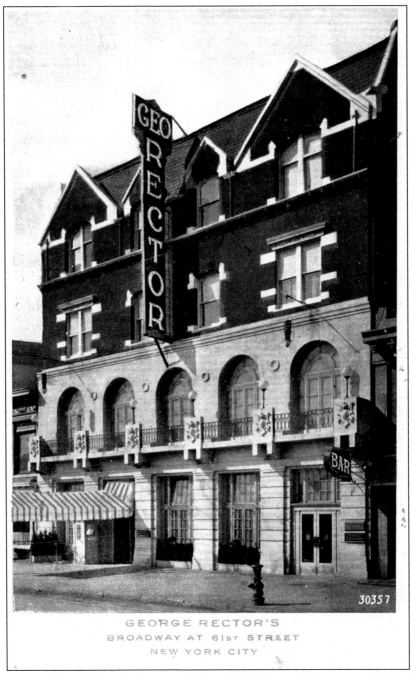

GEORGE RECTOR'S
BROADWAY AT 61st STREET
NEW YORK CITY

George Rector, whose father Charles opened the original Rector's Restaurant for the theatrical trade in Chicago and brought his winning formula to New York's Times Square, established this uptown branch on Columbus Circle. As was the fate of many restaurants and nightclubs in the city, Rector's succumbed to Prohibition. The building, however, is the only survivor of the continual redevelopment of the area (pages 12–13). Originally 15–17 Boulevard (1890), it is now 1845–47 Broadway and hides behind a layer of white brick and fire escapes. (Collection of Bob Stonehill.)

The Tichenor–Grand Company built this magnificent seven-story building on West 61st Street between Broadway and Central Park West in 1906. Here they sold horses and carriages, with "unexcelled boarding accommodation for 300 horses." It was, however, an inauspicious time for the horse-and-carriage trade. (Collection of Bob Stonehill.)

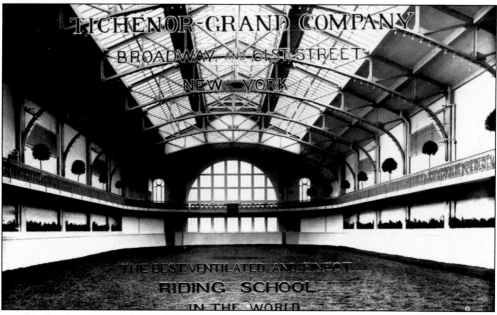

Until its bankruptcy in 1911 and the sale of the building to the United States Motor Company, Tichenor-Grand provided its patrons with festivals and shows of unparalleled skill, artistry, and humor. Indoor fox hunts, women's horseback potato races, men's bareback basketball, alternated with the standard fare of steeplechases, high jumping, and polo matches, much of it in this double-height top floor arena.

By 1904, the apartment hotel had reached Columbus Circle with the opening of the Jermyn Hotel (Mulliken and Moeller), originally called the Pasadena. Bridging the gap between the boardinghouses and traditional hotels, it continued as the Midtown Hotel until rebuilt as the New York Institute of Technology in 1964.

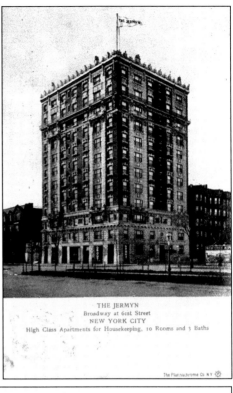

THE JERMYN
Broadway at 61st Street
NEW YORK CITY
High Class Apartments for Housekeeping, 10 Rooms and 3 Baths

The Phostachrome Co. N.Y.

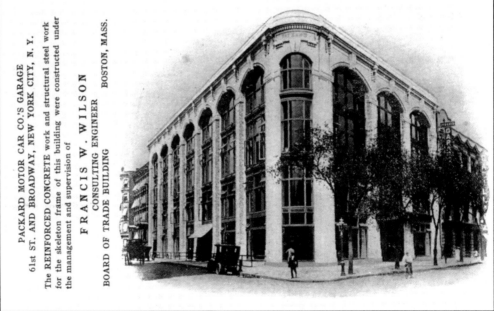

PACKARD MOTOR CAR CO.'S GARAGE
61st ST. AND BROADWAY, NEW YORK CITY, N. Y.

The REINFORCED CONCRETE work and structural steel work for the skeleton frame of this building were constructed under the management and supervision of

FRANCIS W. WILSON
CONSULTING ENGINEER       BOSTON, MASS.
BOARD OF TRADE BUILDING

Just as the theaters and restaurants of midtown made their way north, so did the automobile dealers. By 1907, Broadway, from Columbus Circle to West 70th Street, was home to showrooms for Cadillacs, Duryeas, Daimlers, and Studebakers, among many others. The Packard Motor Car Company's Garage (1906, Albert Kahn) was located at the northwest corner of Broadway and West 61st Street until razed for the American Bible Society building in 1966.

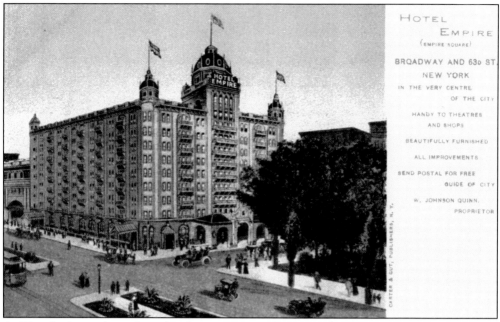

At Lincoln Square's southern border at West 63rd Street, where the Boulevard and Ninth (Columbus) Avenue meet, stands one of the West End's oldest establishments. The Hotel Empire opened in 1894 facing Empire Park (now Dante Park, after the statue placed there in 1921). Notice the tenement flats to the right and the Colonial Theatre, famous for its vaudeville acts, to the left.

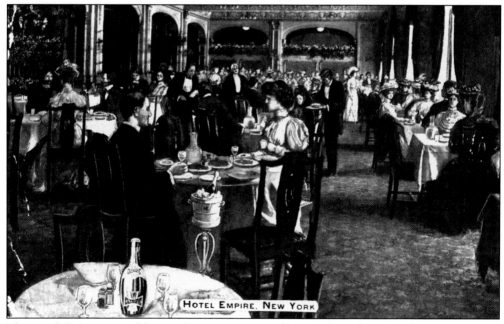

The grand dining room of the Hotel Empire is pictured here in the early years of the 20th century. This card was postmarked New Year's Day in 1909 and carried the sentiment "In New York it's the Hotel Empire and the water 'Clysmic.' Come on in—it's fine." This was an advertisement for the prominently placed bottle of mineral spring water from Wisconsin infused with lithia salts.

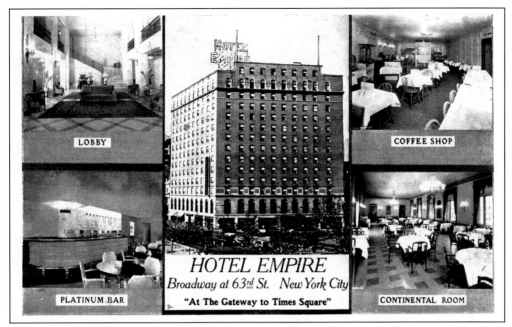

In 1921, the original building was razed, and a new $4 million Hotel Empire was built (Frederick I. Merrick). A brick box with little to distinguish it, a large neon sign was added to attract attention. Despite recent renovations to the interior and ground floor storefronts, this bland exterior is what still graces one of the most conspicuous crossroads in the city.

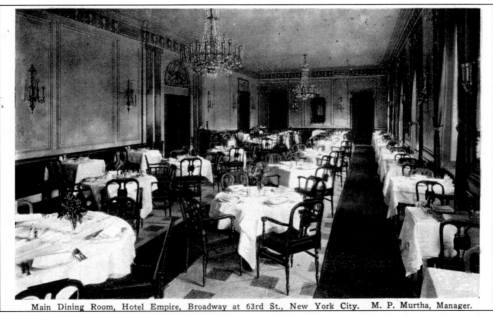

Main Dining Room, Hotel Empire, Broadway at 63rd St., New York City.   M. P. Murtha, Manager.

The main dining room of the second Hotel Empire lacks the musicians and liveliness of its earlier counterpart becoming more of a staid hotel dining room than a dinner destination in itself. In fact, the area had changed to such an extent that by the 1940s, the hotel was advertising itself "At the Gateway to Times Square," rather than playing up its vicinity to the fading amusements of Columbus Circle.

Lincoln Square, New York City.

This is the northern end of Lincoln Square at West 66th Street where Broadway continues up to the left and Columbus Avenue up to the right under the elevated structure. In this 1909 view, the gabled turret of the 22nd Regiment Armory building (1888–1891) is to the left of center with the silhouette of the Ansonia Hotel (page 56) in the distance.

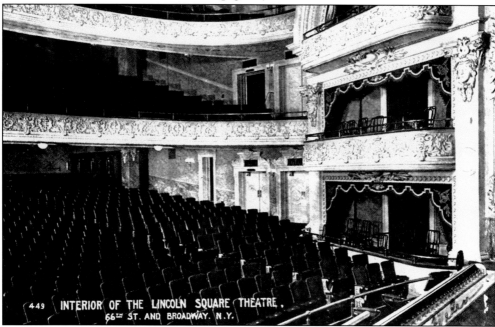

449 INTERIOR OF THE LINCOLN SQUARE THEATRE, 66ᵗʰ ST. AND BROADWAY. N.Y.

In 1906, the Shuberts had great hopes for the Lincoln Square Theatre, bragging that it seated over 1,600 and was the most fireproof theater in the world with the only "water curtain." It had difficulty attracting Broadway-caliber shows and was leased to Charles E. Blaney, the most successful manager of popular-priced attractions (moving pictures, vaudeville), in 1907. Later it was the site of the Lincoln Arcade (1932) and currently, the Juilliard School of Music (1969).

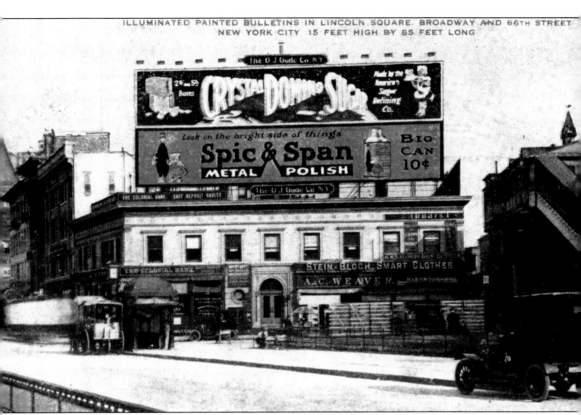

This branch of the Colonial Bank (1898) at West 66th Street lies at the confluence of several mass transit lines. The kiosk of the 66th Street station of the IRT Broadway subway (opened 1904) and the 66th Street station of the Ninth Avenue Elevated (extant 1869–1940) are visible at either end of Empire, now Richard Tucker, Park. Many Upper West Siders recall this as the site of Bank Leumi's striking glass reinterpretation (1962) of the Colonial Bank with the Cinema Studio Theater next door. Future generations will recall the current Barnes and Noble Booksellers at One Lincoln Square (1997).

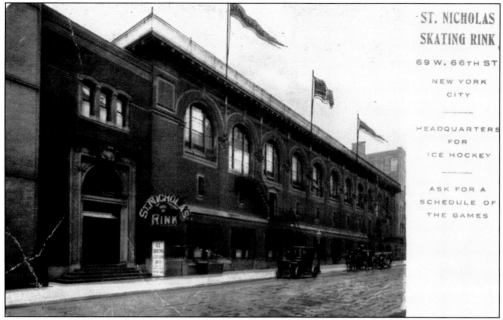

The St. Nicholas Rink (1896, Flagg and Chambers) was located on West 66th Street off Columbus Avenue, neighbor to Thomas Healy's Golden Glades and Durland's Riding Academy (after 1901). It was built by Cornelius Vanderbilt and John Jacob Astor for the St. Nicholas Skating Club. Besides skating, it became home to bicycling, intercollegiate hockey tournaments, figure skating, indoor lawn tennis, and professional boxing as the St. Nicholas Arena. It was razed in the 1980s for ABC television studios.

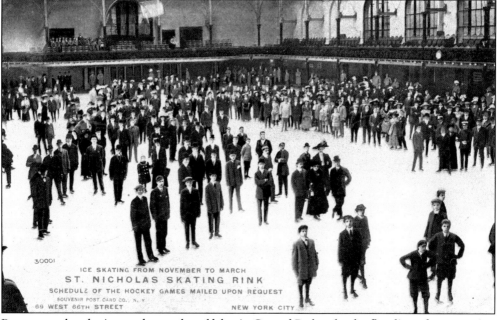

Patrons, used to skating on the ponds and lakes in Central Park or by the flooding of construction sites in winter, found in the St. Nicholas Rink a vast arena with a public viewing gallery above. If one looks closely, the band can be seen in the upper left portion of the gallery.

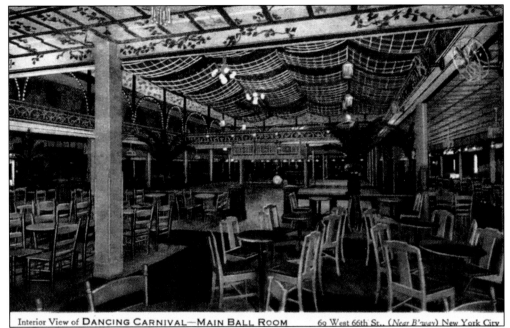

Interior View of DANCING CARNIVAL—MAIN BALL ROOM    69 West 66th St., *(Near B'way)* New York City

For the duration of World War I, the government banned indoor rinks due to the necessity of conserving ammonia, which was used in the artificial ice-making process. Hence the Dancing Carnival arrived at the St. Nicholas Rink, recently moved out of the Grand Central Palace, which was being used for military purposes.

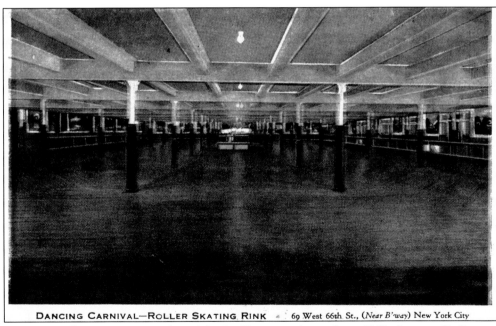

DANCING CARNIVAL—ROLLER SKATING RINK    69 West 66th St., *(Near B'way)* New York City

The skating floor was commandeered for the "largest and most beautifully decorated ball room in America," accommodating over 2,000 people with three large orchestras. Underneath the main ballroom, 22,000 square feet of floor space was available for roller-skating.

25

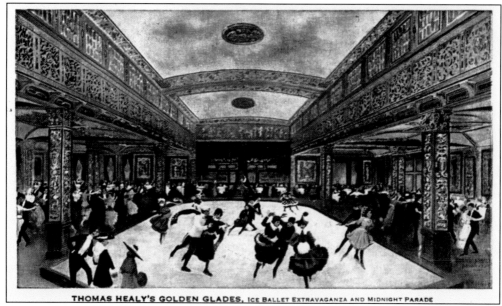

THOMAS HEALY'S GOLDEN GLADES, ICE BALLET EXTRAVAGANZA AND MIDNIGHT PARADE

Tom Healy's Golden Glades, a nightspot popular with politicians, athletes, theater people, and Columbia undergraduates, occupied a four-story building on the northeast corner of Columbus Avenue and West 66th Street, next door to the St. Nicholas Rink. The top floor was home to the world's best skaters in elaborately choreographed ice carnivals, ballets, and midnight parades.

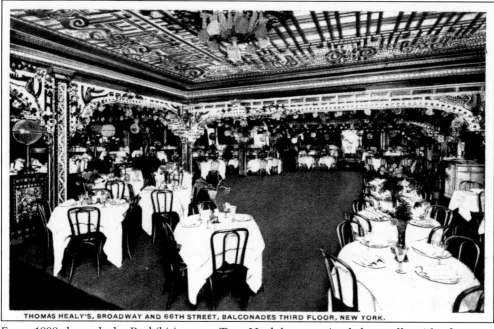

THOMAS HEALY'S, BROADWAY AND 66TH STREET, BALCONADES THIRD FLOOR, NEW YORK.

From 1898 through the Prohibition era, Tom Healy's entertained the swells with afternoon teas, dinner, music, and dancing. It is claimed that Healy introduced cabaret to New York in his third-floor Balconades Ballroom.

# *Two*

# CENTRAL PARK WEST

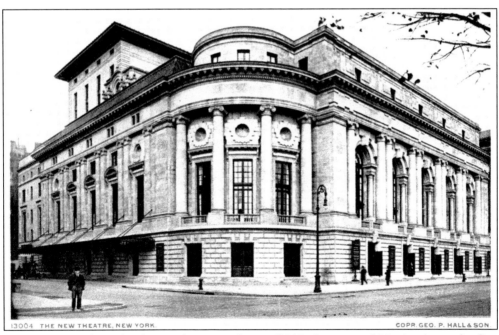

A glorious temple to the drama, the New Theatre (1909, Carrere and Hastings) was the first non-profit theater in America supported by private subscription. Located on the northwest corner of West 62nd Street and Central Park West, the theater was redesigned and renamed the Century Theatre in 1910 after an unsuccessful first season. The art deco Century Apartments (1931, Chanin, Delamarre, and Sloan and Robertson) now occupy the site.

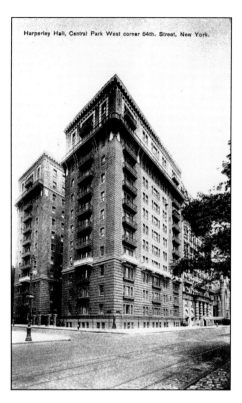

Harperley Hall, Central Park West corner 64th. Street, New York.

Harperly Hall (1910, Henry W. Wilkinson) at the northwest corner of West 64th Street was part of the second wave of luxury apartment house construction on Central Park West. Originally featuring apartments from 2 to 10 rooms, the building had extra rooms for guests and servants. Although the first-class restaurant is gone, the building's exterior has been maintained impeccably, with awnings adorning the balconied windows. (Collection of Bob Stonehill.)

At the northwest corner of West 67th Street was the Town House Hotel and Restaurant. Originally built as the Chatham Court apartment house, it had an elaborate and spiky mansard roof and only three apartments of 2 to 10 rooms per floor. In 1929, 75 Central Park West (Rosario Candela) replaced the Town House. (Collection of Bob Stonehill.)

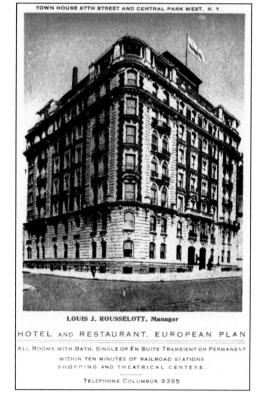

TOWN HOUSE 67TH STREET AND CENTRAL PARK WEST, N. Y.

LOUIS J. ROUSSELOTT, Manager

HOTEL AND RESTAURANT. EUROPEAN PLAN

ALL ROOMS WITH BATH. SINGLE OR EN SUITE TRANSIENT OR PERMANENT
WITHIN TEN MINUTES OF RAILROAD STATIONS
SHOPPING AND THEATRICAL CENTERS.

TELEPHONE COLUMBUS 9395

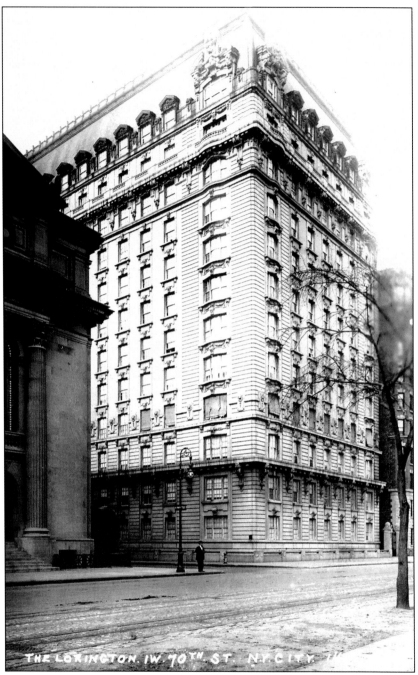

THE LORINGTON. IW. 70TH ST. N.Y. CITY.

Facing Central Park at West 70th Street was the Lorington (1906, Robert T. Lyons), a sumptuous 12-story apartment house with only 35 apartments of 11 and 12 rooms with 3 baths, all with external exposure. One of the most luxuriously appointed houses at the time, with polished mahogany finishes and vitrified tile floors with artistic borders, tenants could boast being able to make their own ice by simply placing a can filled with water in the "freezing chamber" of their refrigerator box. The Lorington was demolished in 1929 and replaced with the huge red brick 101 Central Park West (1930, Schwartz and Gross). (Collection of Bob Stonehill.)

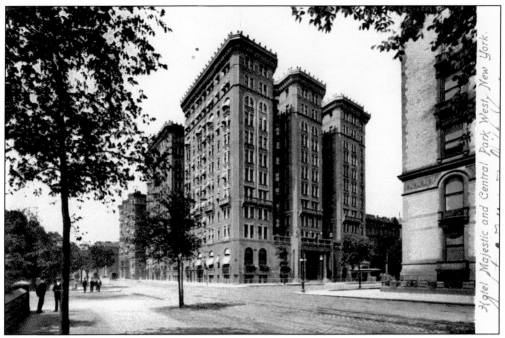

In the 1890s, the gateway to the West End from the east was along West 72nd Street, a premier residential street lined with a great variety of town houses. On the south side of its intersection with Central Park West stood the Hotel Majestic; on the north side stood the Dakota (page 33). Behind the Majestic on West 71st Street is the Minnesota (1895).

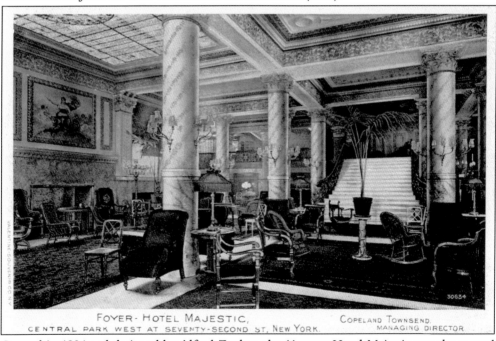

FOYER · HOTEL MAJESTIC,
CENTRAL PARK WEST AT SEVENTY-SECOND ST, NEW YORK.

COPELAND TOWNSEND.
MANAGING DIRECTOR

Opened in 1894 and designed by Alfred Zucker, the 11-story Hotel Majestic was the second tallest on the thoroughfare, and the first with a roof garden. Its opulent interiors were renowned and attracted an elite clientele including Sarah Bernhardt, Edna Ferber, and Enrico Caruso.

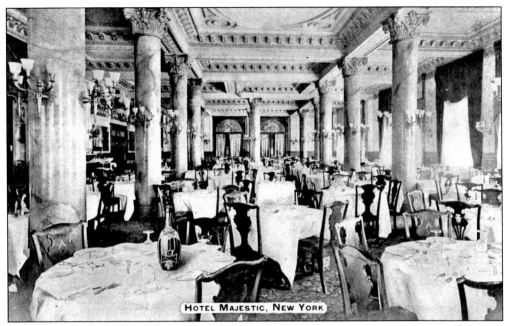

Originally envisioned as a vast hall whose columns supported gothic fan vaults, the dining room was built in a classical style more in keeping with the hotel's exterior and lobby. Notice the Clysmic Water on the table in the foreground.

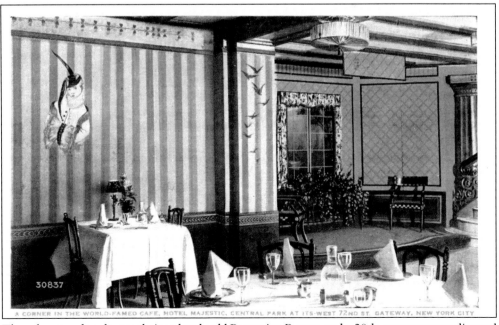

Though not as decadent as their red and gold Pompeian Room, early-20th-century tastes dictated something of a more casual and charming nature in this café setting.

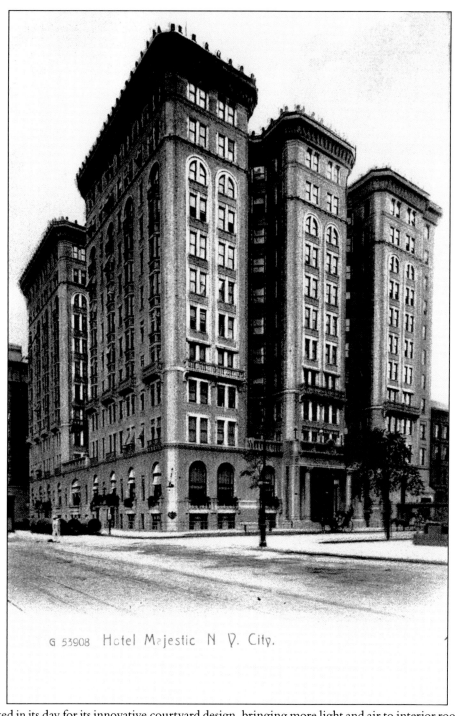

G 53908 Hotel Majestic N Y. City.

Noted in its day for its innovative courtyard design, bringing more light and air to interior rooms, as well as for its less-restrictive social policies, it was derisively referred to as "the Jewish place," the Hotel Majestic fell to the last wave of apartment house building in the years preceding the Depression. It was replaced by the Chanins' art deco masterpiece, the twin-towered, 32-story Majestic Apartments (1931, Chanin, Delamarre, and Sloan and Robertson).

Henry Janeway Hardenbergh (1847–1918) was the architect commissioned by Edward S. Clark, a partner in the Singer Sewing Machine Company, to change the face of development of the Upper West Side forever, when in 1882–1884 he designed the Dakota apartment house on West 72nd Street. In addition to many town houses in the surrounding area, Hardenbergh went on to design the Plaza Hotel (1907) and the original Waldorf (1893) and Astoria (1897) hotels.

HENRY JANEWAY HARDENBERGH

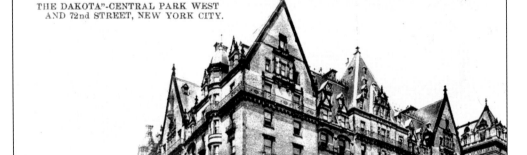

Arguably the most famous apartment house in the world, the Dakota has weathered much notoriety over the years and now suffers from a constant glut of tourist buses. One can watch *Rosemary's Baby* if one wants to get a sense of what the building has meant to generations of New Yorkers. This photograph was taken in 1907, shortly after the building of the Langham (Clinton and Russell) to the north. (Collection of Bob Stonehill.)

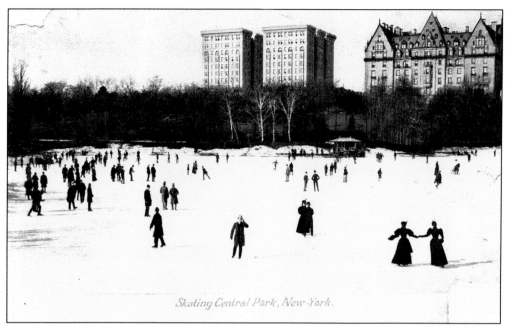

*Skating Central Park, New-York.*

Although postmarked in 1908, this image is much earlier, likely 1894, shortly after the Hotel Majestic was completed. Looking west across Central Park from Vista Rock, one can see skaters, mostly men, on the lake. Women and children had their own section in which to skate on the north end of the lake.

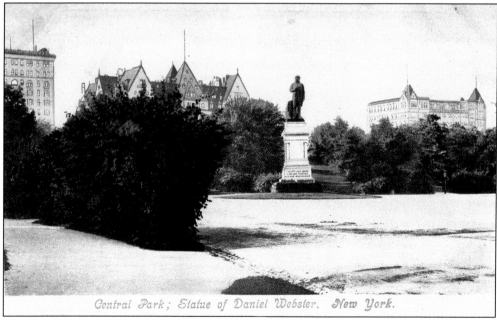

*Central Park; Statue of Daniel Webster. New York.*

This view across Central Park to the northwest shows the prominent placement of the monument to congressman, senator, and secretary of state Daniel Webster (1782–1852) renowned for his eloquence and oratory. It is flanked by the burgeoning "skyscraper" skyline of the early wave of development along Central Park West—the Hotel Majestic, Dakota, and the Hotel San Remo. Missing is the Langham, which helps date this card prior to 1907.

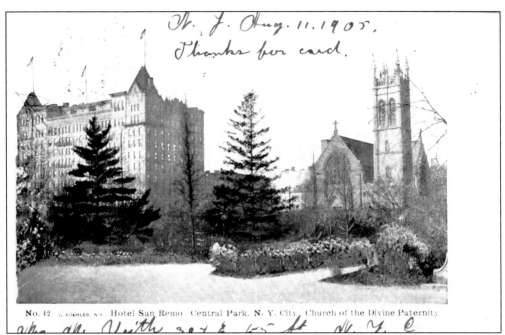

*N. J. Aug. 11. 1905,*
*Thanks for card.*

No. 42  J. KOEHLER, N.Y.  Hotel San Remo  Central Park, N. Y. City  Church of the Divine Paternity

*who all Unith 30 x 6 155 ft  N. Y. C*

The Hotel San Remo occupied the entire blockfront from West 74th to West 75th Streets in this 1905 view. Opened in 1891, it was designed by Edward L. Angell, the architect of several west side row houses, apartment houses, and the spectacular Hotel Endicott (page 82). The hotel was razed in 1928 for the San Remo Apartments (1930, Emery Roth), the first of four twin-towered apartment houses on Central Park West.

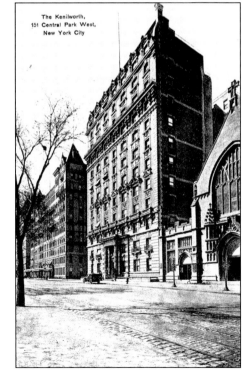

The Kenilworth,
151 Central Park West,
New York City

In 1908, the Kenilworth (Townsend, Steinle and Hackle) filled the lot between the Hotel San Remo and the Church of the Divine Paternity. At the time, the *New York Times* claimed that it "typifies all that is most desirable in the modern methods of living in the metropolis." There were ample closets, telephone and mail service, fireproof wall safes, and every suite commanded an extensive view of Central Park.

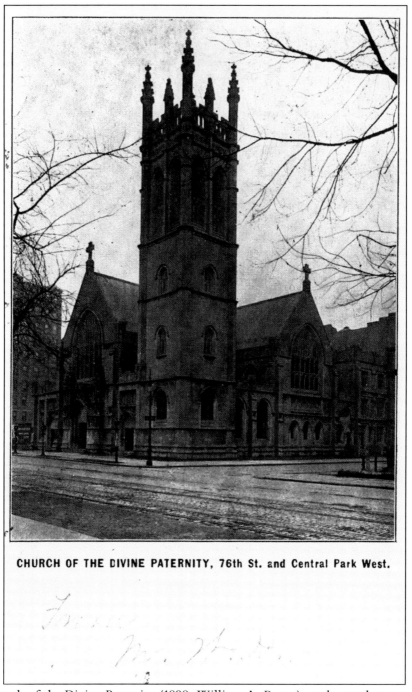

**CHURCH OF THE DIVINE PATERNITY, 76th St. and Central Park West.**

The Church of the Divine Paternity (1898, William A. Potter), at the southwest corner of West 76th Street, houses the Fourth Universalist Society, a Unitarian Universalist congregation founded in 1838. The sanctuary features a Tiffany altar and relief sculpture by St. Gaudens. The gothic tower on the corner is a replica of a medieval tower at Magdalen College, Oxford. The sole survivor of seven Universalist churches in New York City, it still welcomes all congregants without regard for race, religion, ethnicity, or lifestyle.

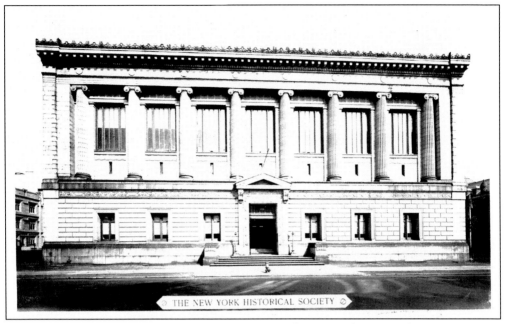

The New York Historical Society tends four centuries of American history and art in its museum and library at 170 Central Park West between West 76th and West 77th Streets. It is the eighth home of the institution since its founding in 1804. This view shows the York and Sawyer–designed central section of the building that opened to the public in 1908. (Collection of Joseph Ditta.)

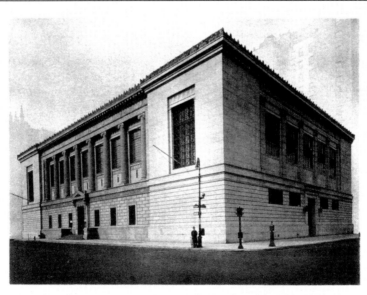

The original plans called for flanking wings on the north and south, but these were not built until a generous bequest during the Depression made completion possible. Walker and Gillette (1938) designed the wings following the York and Sawyer plan closely, but not entirely; notice the flattened pilasters on the West 77th Street facade, which mimic the semi-detached colonnades on Central Park West. (Collection of Joseph Ditta.)

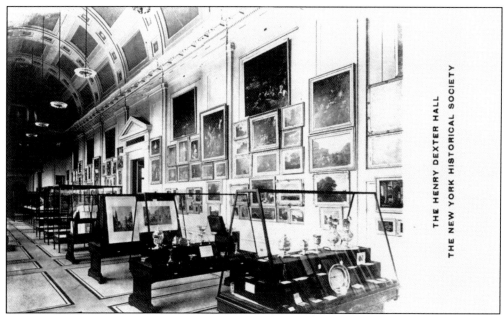

President of the American News Company, a founder of the Metropolitan Museum of Art, and member of the New York Historical Society since 1863, Henry Dexter (1813–1910) gave substantially toward the completion of the society's new home. Although resisting attempts, including legal ones, to have the building named for Dexter's murdered son, the society nonetheless honored Dexter by naming its main gallery Henry Dexter Hall. (Collection of Joseph Ditta.)

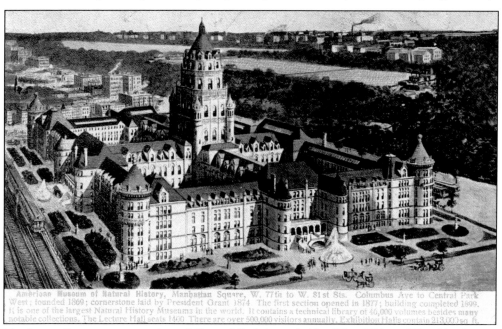

American Museum of Natural History, Manhattan Square, W. 77th to W. 81st Sts. Columbus Ave to Central Park West ; founded 1869 ; cornerstone laid by President Grant 1874  The first section opened in 1877; building completed 1899. It is one of the largest Natural History Museums in the world. It contains a technical library of 46,000 volumes besides many notable collections. The Lecture Hall seats 1400  There are over 500,000 visitors annually. Exhibition Halls contain 213,000 sq. ft.

Manhattan Square, an extension of Central Park bounded by West 77th to West 81st Streets from Central Park West to Columbus Avenue, was the site chosen for the American Museum of Natural History shortly after its conception in 1869. This is an 1897 illustration of the master plan envisioning four great courtyards and a massive central tower.

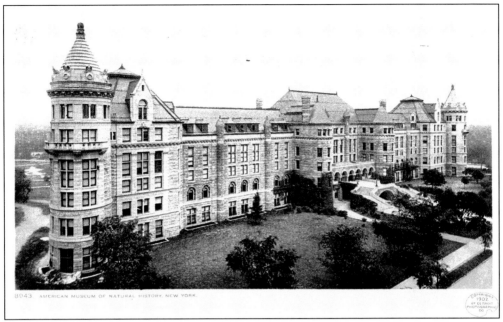

The 1899 completion of the West 77th Street facade of the museum (Cady, Berg and See) created New York's longest continuous facade; with 62-foot-long box girders, it was an engineering marvel creating column-free exhibit space. The original museum building, completed in 1877 and designed by Calvert Vaux and Jacob Wrey Mould, is perpendicular to, and hidden behind, the central portion of this structure.

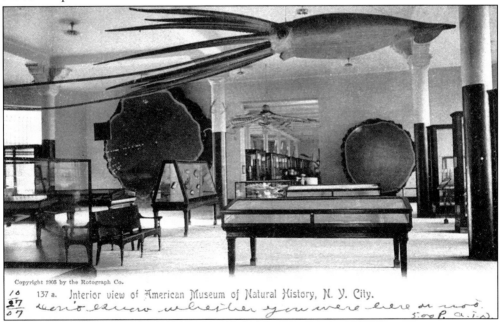

137 a.  Interior view of American Museum of Natural History, N. Y. City.

Displays in the new museum were contemporary and the metal and glass vitrines state-of-the-art. The giant sequoia at left was over 1,300 years old and over 300 feet high when felled in 1891; it is over 16.5 feet in diameter. The giant squid in the upper foreground is one of the oldest models still in use in the museum. Purchased in 1895, it is made of papier-mâché and is 42 feet long.

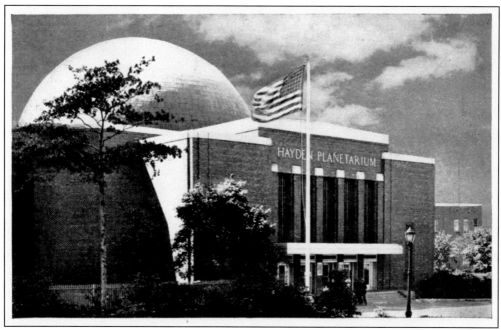

The first Hayden Planetarium (Trowbridge and Livingston) was known to all New York City schoolchildren from 1935 to its reconstruction within the expanded Rose Center for Earth and Space (2000, Polshek Partners). This diminutive, forlorn, redbrick building with its squat dome was beloved by generations, but always in the shadow, both literally and figuratively, of its parent organization to the south, the American Museum of Natural History.

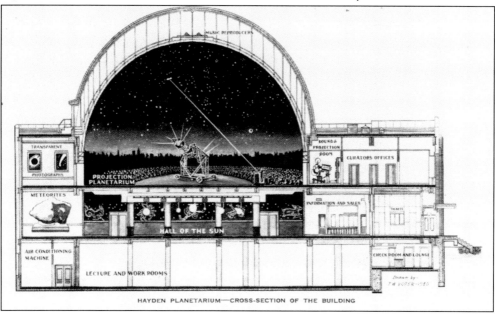

A cross-section of the planetarium building shows the main projection hall under its perforated stainless steel dome. Below this on the main floor was the Hall of the Sun, where the six inner planets made their rotation and revolution around the sun. Exhibited throughout the corridors were 54 tons of meteorites.

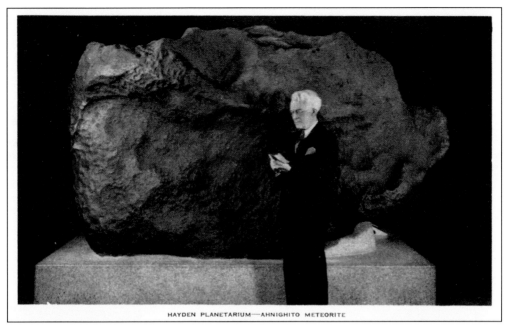

The Hayden Planetarium displayed over 3,000 meteorites, but none larger than the Ahnighito, a 36.5-ton iron chunk of the original Cape York meteorite. Ahnighito was brought from Greenland to the United States by Adm. Robert Peary in 1905. Dr. Clyde Fisher, the planetarium's first curator-in-chief, is purportedly examining a fragment of the meteorite.

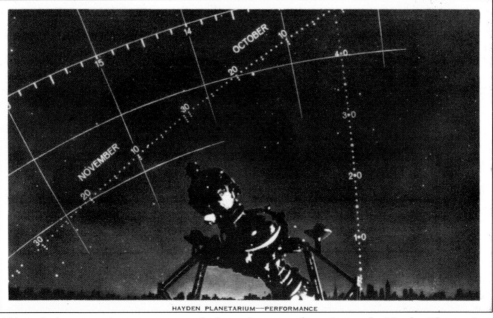

Although the meteorites were way cool, the main reason for going to the Hayden Planetarium was the sky show. When the lights were dimmed and the Zeiss projector was moved into position, over 3,000 stars were projected onto the heavens above, making it appear as if the ceiling faded away and the sky was revealed. The superimposition of the Manhattan skyline around the base of the dome heightened this illusion.

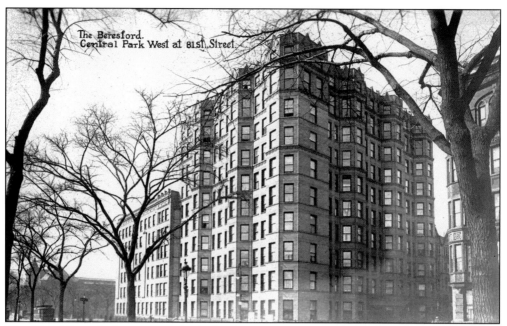

The Hotel Beresford was comprised of a six-story structure built in 1889 on the corner of West 81st Street and a 10-story structure built five years later on the West 82nd Street corner. In 1928–1929, Emery Roth designed the triple-towered Beresford Apartments in their place. (Collection of Bob Stonehill.)

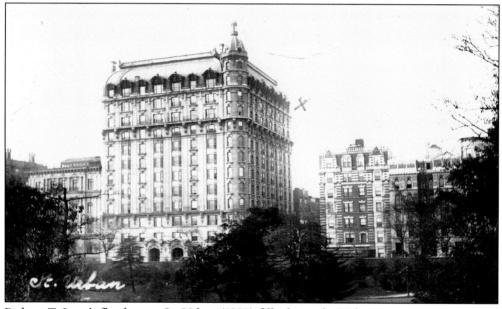

Robert T. Lyon's flamboyant St. Urban (1905) fills this early-20th-century streetscape with an exuberance that continued to set Central Park West apart from the tony avenues of the East Side. To its left stands the Progress Club (1904, Louis Korn), later the Walden School and 279 Central Park West (1999, Constantine Kondylis). Across West 88th Street on the right are an apartment hotel at 291 (1899, Clarence True) and a flats building at 293 (1896, Neville and Bagge), both are extant.

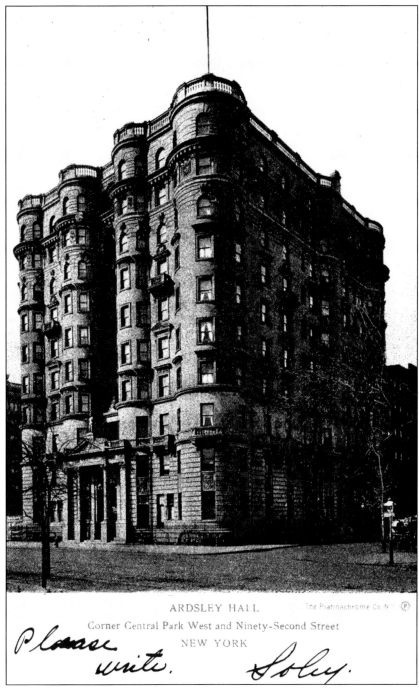

ARDSLEY HALL

Corner Central Park West and Ninety-Second Street

NEW YORK

Advertised as the finest apartment house on the west side when it opened in 1900, Ardsley Hall at West 92nd Street appears to have been little more than a glorified tenement house with telephones and safes in each apartment. A truly novel feature was its handsomely furnished and decorated entertaining rooms for private receptions of the tenants of the building. Ardsley Hall was razed in the late 1920s and replaced with the dramatic Mayan art deco Ardsley Apartments (1931, Emery Roth).

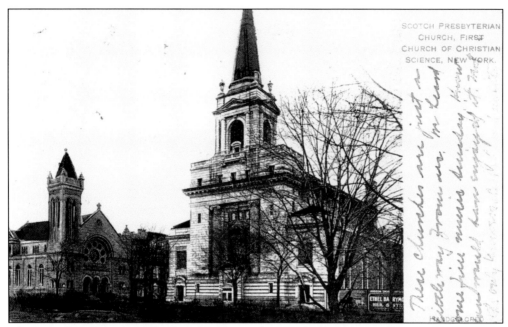

The Second Presbyterian Church, referred to as the Scotch Presbyterian Church, built its fourth sanctuary on the southwest corner of West 96th Street in 1893–1894 (William H. Hume and Son). It was later incorporated into the 16-story 360 Central Park West (1929, Rosario Candela). Across the street, facing Central Park, is the First Church of Christ Scientist (1903, Carrere and Hastings). (Collection of Bob Stonehill.)

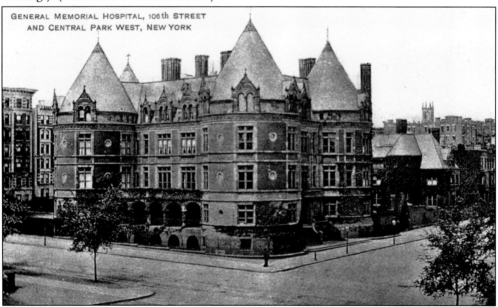

General Memorial Hospital, 106th Street and Central Park West, New York

Founded in 1884, the New York Cancer Hospital (1884–1890, Charles C. Haight) at West 106th Street was the first in the nation to focus solely on cancer treatment. It became the General Memorial Hospital around 1900, a precursor to Memorial Sloan-Kettering Cancer Center. Now it is the anchor of a large condominium complex known as 455 Central Park West. (Collection of Bob Stonehill.)

# *Three*

# BROADWAY

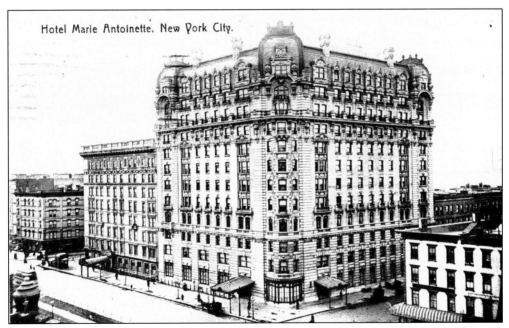

On the west side of Broadway from West 66th and West 67th Streets was the Hotel Marie Antoinette, later the Hotel Dauphin. As with the Beresford, this hotel was actually two buildings. The modern French-style addition on West 67th Street was the work of C. P. H. Gilbert in 1903. It is now the site of the Grand Millennium (1996), which, until a few years ago, was the home of the sorely missed Tower Records.

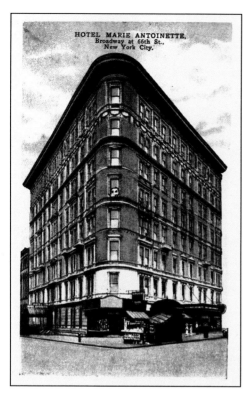

The original Hotel Marie Antoinette (1895, Julius Munckowitz) was a charming eight-story building that curved around the northwest corner of West 66th Street. Built before the IRT subway was begun, it was a modest, yet refined, hotel with dark wood paneling and heavy drapery. This view was taken shortly after the subway arrived in 1904. (Collection of Bob Stonehill.)

The New York College of Pharmacy, chartered in 1829, was the second-oldest school of its kind in the nation. It became the department of pharmacy of Columbia University in 1904. Regardless of the postcard caption, its home, completed in 1894 to designs of Little and O'Connor, was at 115 West 68th Street between Broadway and Columbus Avenue. It is now the site of the parking lot for the Copley (1987, Davis Brody and Associates).

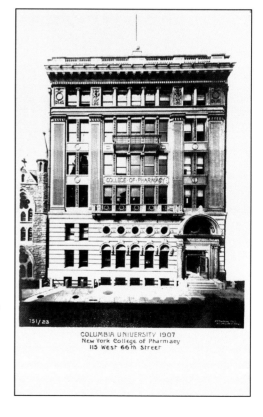

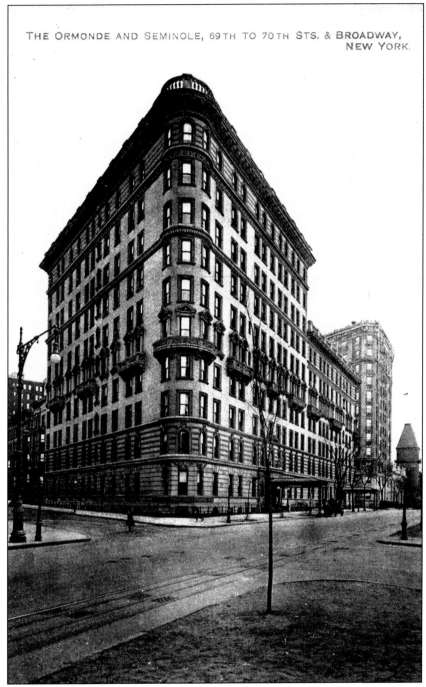

The high-class seven-story Seminole (1896, Ware and Styne-Harde) and the 10-story Ormonde (1900, Robert Maynicke) are on the east side of Broadway between West 69th and West 70th Streets. In 1905, when this image was taken, rents ranged from $2,200 to $3,000 per year. An additional two stories were added to the Ormonde in 1908. Retail stores incorporated into both buildings and the fire escapes added to the Seminole in the 1920s obscure the attempts to create a continuous facade between the two buildings. (Collection of Bob Stonehill.)

BROADWAY, NORTH OF 69TH STREET, New York City.

On the west side of Broadway from West 69th Street to Sherman Square, the intersection of Broadway and Amsterdam Avenue, is the Nevada. Built as a middle-class apartment house in the early 1890s, by the 1970s, the Nevada was a dangerous and decrepit residential hotel. It is now the site of the 28-story Nevada Towers (1977, Philip Birnbaum).

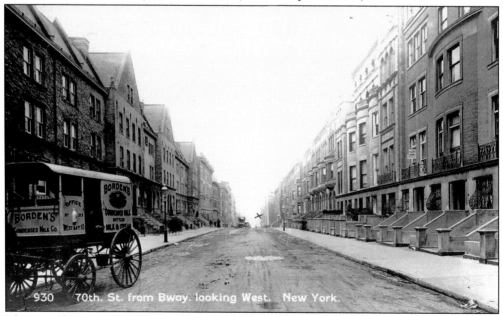

930   70th. St. from Bway. looking West.   New York.

The town houses and apartment flats along West 70th Street from Amsterdam to West End Avenues provide a rather rhythmic and symmetrical streetscape in the waning years of the 19th century. Redevelopment and slum clearance has caused this block to lose all cohesion, as apartment houses large and small mix with a playground and school and the few remaining town houses on the right of the image. (Collection of Bob Stonehill.)

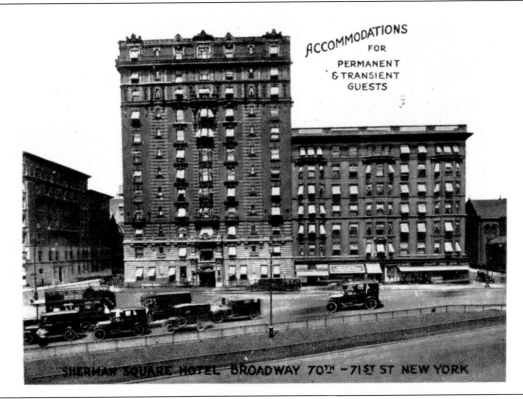

ACCOMMODATIONS FOR PERMANENT & TRANSIENT GUESTS

SHERMAN SQUARE HOTEL BROADWAY 70TH - 71ST ST NEW YORK

Gen. William Tecumseh Sherman's death in 1891 was a time of great bereavement in the West End where he spent his waning years in a town house on West 71st Street. It was then that the great Civil War hero's name was given to the square, actually the triangle at the intersection of Broadway and Amsterdam Avenue, and to the seven-story Sherman Square Hotel (1892). The hotel later expanded to include the Regent Hotel to its south on West 70th Street. Both buildings were razed in 1969 for the 42-story One Sherman Square (1971, S. J. Kessler).

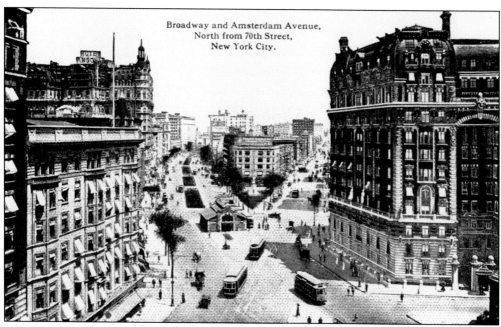

Broadway and Amsterdam Avenue,
North from 70th Street,
New York City.

This view north up Broadway and Amsterdam Avenue (to the right) is from the top of the Nevada Apartments on Sherman Square. Notable structures include the Sherman Square Hotel at left, the Ansonia Hotel (page 56), the 1904 Heins and LaFarge IRT express station kiosk at 72nd Street, Verdi Square in the center, and the Dorilton at the right.

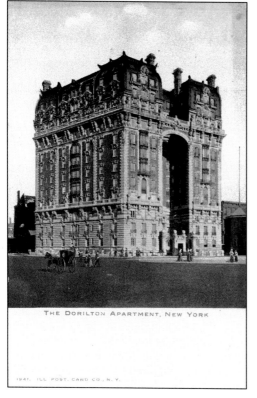

THE DORILTON APARTMENT, NEW YORK

1941. ILL POST. CARD CO., N. Y.

Although critically lampooned upon completion for its ostentation and its "look at me" qualities, the Dorilton has been much beloved on the Upper West Side since its completion in 1902. Created by Janes and Leo, in the style of, but on a much larger scale than, their Alimar at West End Avenue at West 105th Street, its ornament and decoration has remained either remarkably intact or has been painstakingly restored since turning cooperative in 1984.

St. & Bway. New York.

Once upon a time in the West End, churches had Broadway frontages. Christ Church (1890, Charles C. Haight), established in 1793 as the second-oldest Episcopal church in New York, built its fifth home at the northwest corner of Broadway at West 71st Street. In 1925, the church was truncated and lost its tower for the Lester Building; the rest of the sanctuary was razed in the mid-1980s for the Lincoln Park Apartments. The Venetian palazzo parish house remains on West 71st Street. (Collection of Bob Stonehill.)

The Lucania, 235 W. 71st St., New York.

Walk down any street on the Upper West Side and one will find an apartment house like 235 West 71st Street (1912, Gaetan Ajello); one that breaks the rhythm of the row houses and brings its footprint to the property line to maximize rental space. Having lost its cornice and its balconies over the decades, it is now undergoing a 21st-century transformation.

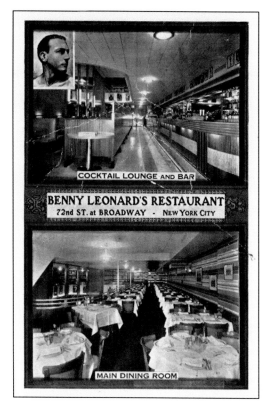

COCKTAIL LOUNGE AND BAR

BENNY LEONARD'S RESTAURANT
72nd ST. at BROADWAY - NEW YORK CITY

MAIN DINING ROOM

Former boxer and undefeated lightweight champion Benny Leonard (1896–1947), the "Ghetto Wizard" from the Lower East Side, opened a steak and lobster restaurant in 1937 at 174 West 72nd Street off Broadway. In addition to hosting, he also taught boxing and refereed at the St. Nicholas Arena (page 24) where he died of a heart attack, in the ring, in 1943.

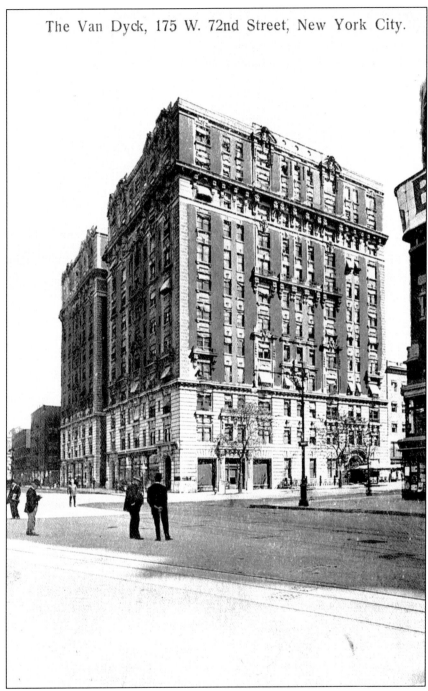

The Van Dyck, 175 W. 72nd Street, New York City.

Literally at the crossroads of the Upper West Side, the Van Dyck and Severn apartment houses (1906, Mulliken and Moeller) sit on the east side of Amsterdam Avenue, between West 72nd and West 73rd Streets, overlooking Sherman Square, Verdi Square, and the new express subway in this 1910 view. Covered with what must be the heaviest terra-cotta ornamentation in the entire area, boasting large and elegant vitrines, and donning an unusual cornice two floors below the roofline, they were, and remain, two of the grand dames of the Upper West Side.

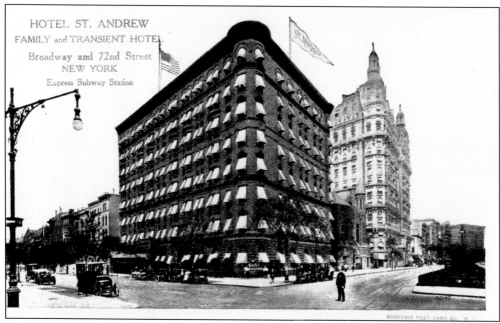

The Hotel St. Andrew (1897, Andrew Craig) stood on the northwest corner of Broadway and West 72nd Street. A modest hotel, it was quickly dwarfed by the subway-era hotels and apartment houses, like the Ansonia to its north. For many years the site of a two-story taxpayer, which housed the Embassy movie theater, it is now the site of the Alexandria.

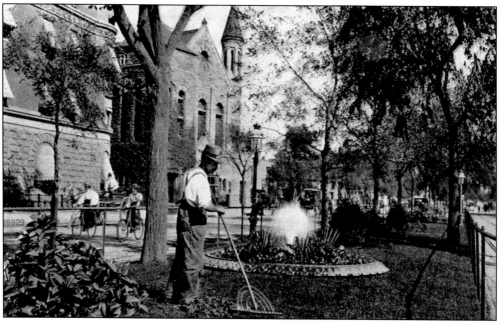

By the 20th century, this tranquil, well-tended island was in the center of Broadway from West 72nd to West 73rd Streets. It was only a matter of months before this section of Broadway would be in tremendous upheaval due to the cut-and-cover construction of the subway and the building of the Ansonia apartments to the north of the original location of the Rutgers Presbyterian Church (1890, R. H. Robertson) at West 73rd Street.

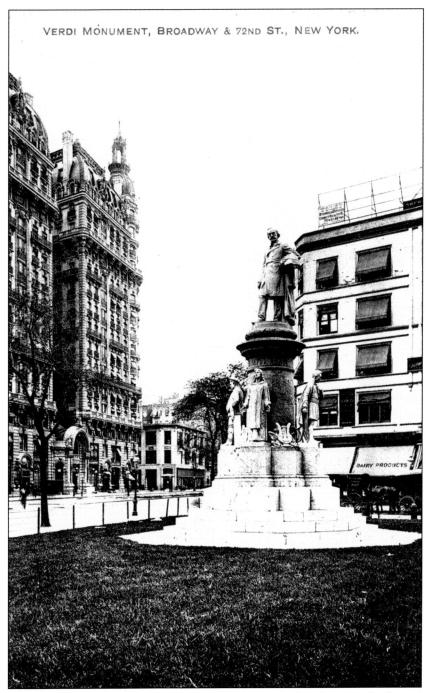

A favorite gathering place of the famous musicians who made their home at the Ansonia across the street, the northern triangle of Sherman Square at West 73rd Street, features this monument of Italian composer Giuseppe Verdi, created in 1906 by Pasquale Civiletti. The park, renamed Verdi Square in 1921, is now part of the pedestrian zone created around the 73rd Street entrance to the IRT subway. The Sherman apartment house with its Sheffield Farms dairy store would give way to the massive Central Savings Bank (York and Sawyer) in 1928.

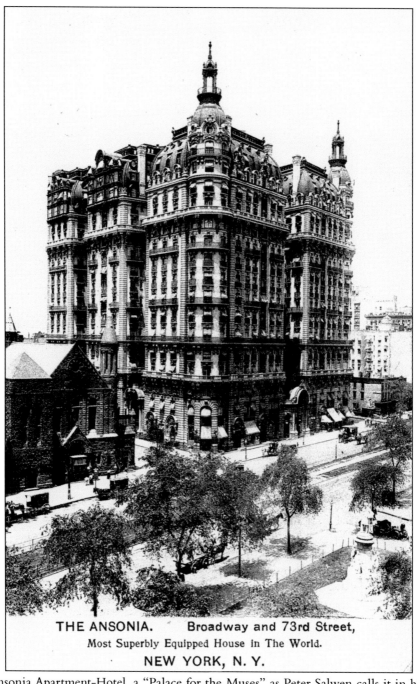

**THE ANSONIA.** Broadway and 73rd Street,
Most Superbly Equipped House in The World.
**NEW YORK, N. Y.**

The Ansonia Apartment-Hotel, a "Palace for the Muses" as Peter Salwen calls it in his book *Upper West Side Story*, was a haven for theatrical personalities, opera singers, composers, musicians, writers, and sports legends. No doubt drawn to the building by its exuberant exterior, they were likewise attracted by the thick interior walls, originally designed for temperature control (freezing brine was pumped through them in summer). Noted at the time for its use of recessed courts—two on West 73rd Street, one on Broadway, and two on West 74th Street—it is a confection of balconies and balustrades, mansards and cupolas.

The Ansonia, designed by French architect Paul E. M. Duboy, was built from 1899 to 1904 for developer William Earl Dodge Stokes (1852–1926). Stokes, the son of Ansonia copper heiress Caroline Phelps, was an early proponent of development in the West End, building dozens of town houses and tenements before turning to his dream of transforming the Grand Boulevard (Broadway) into the Champs-Elysees of New York.

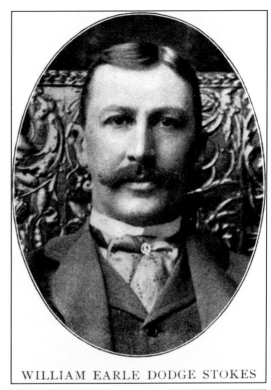

WILLIAM EARLE DODGE STOKES

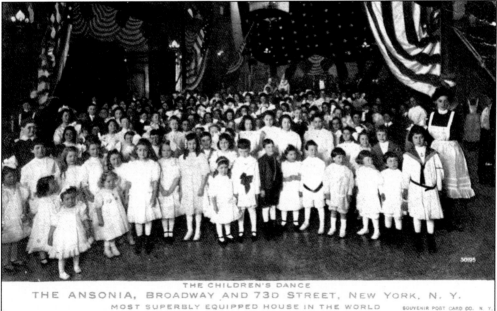

THE CHILDREN'S DANCE
THE ANSONIA, BROADWAY AND 73D STREET, NEW YORK, N. Y.
MOST SUPERBLY EQUIPPED HOUSE IN THE WORLD    SOUVENIR POST CARD CO.  N. Y.

The major public rooms of the Ansonia included the Palm Garden, Assembly Room, Grill Room, and in the central courtyard on Broadway, a glass-canopied restaurant. It was in one of these rooms that the Ansonia hosted a surprise party for its child guests on George Washington's birthday, February 22, 1910. With 2,500 rooms on 17 floors, it is not surprising that the event was well attended. (Collection of Bob Stonehill.)

LOOKING SOUTHWARD

THE ANSONIA, BROADWAY AND 73D STREET.  MOST SUPERBLY EQUIPED HOUSE IN THE WORLD.

NEW YORK. N. Y.

It was said that due to the curve in Broadway at West 73rd Street, the Ansonia could be seen from Columbus Circle all the way to West 105th Street. Looking south over Sherman Square from the top of the Ansonia in 1909 was equally impressive. The Dorilton is on the far left, the Marie Antoinette just left of center, with the Nevada in front of it; the two buildings comprising the Sherman Square Hotel are behind the tower of Christ Church.

Looking Northward

THE ANSONIA. Broadway and 73rd Street.  Most Superbly Equipped House in The World.

NEW YORK, N. Y.

The view to the north along Broadway shows the Astor Apartments at West 75th Street in the left foreground; behind it are the Hotel Belleclaire at West 77th Street and the Apthorp at West 79th Street. In the far distance, the erection of the Belnord at West 86th Street can be seen.

58

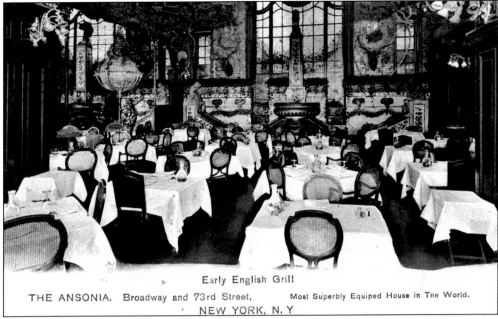

Early English Grill

THE ANSONIA. Broadway and 73rd Street,     Most Superbly Equiped House in The World.
NEW YORK, N. Y.

The Early English Grill Room was described as a "feature of the Ansonia more novel and pleasing than can be described. It is a most unique touch." Not the main restaurant of the apartment hotel, it was popular among those tenants and New Yorkers looking for a quiet evening out in the West End, known for its rowdy and risqué establishments further south.

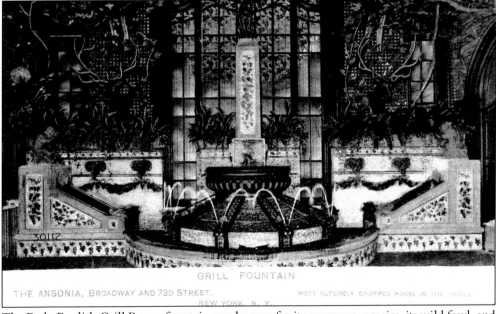

GRILL FOUNTAIN

THE ANSONIA, BROADWAY AND 73D STREET.     MOST SUPERBLY EQUIPPED HOUSE IN THE WORLD.
NEW YORK, N. Y.

The Early English Grill Room fountain was known for its gorgeous mosaics, its wild fowl, and many fish. Its ornamentation, consisting of bears, elephants, monkeys, and deer was a favorite among the children, some of whom gave concerts and recitals in the room. The fountain is long gone, but the elegant window behind it has been restored and now graces the store at the corner of West 73rd Street and Broadway.

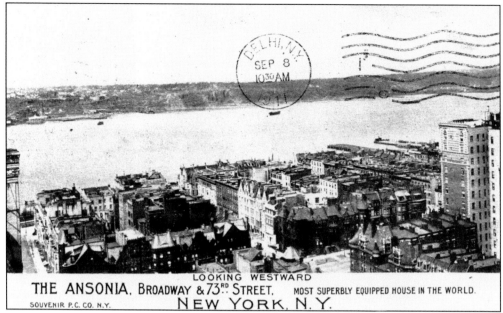

LOOKING WESTWARD

THE ANSONIA, BROADWAY & 73RD STREET. MOST SUPERBLY EQUIPPED HOUSE IN THE WORLD.

SOUVENIR P.C. CO. N.Y. NEW YORK, N.Y.

Looking west toward the Hudson River in 1909 from the roof of the Ansonia highlights the row house development from West 74th to West 76th Streets along West End Avenue, in the foreground, to Riverside Drive. The elegant gabled and turreted town houses along West End Avenue, seen here, would all shortly give way to apartment houses like 330 West End Avenue at the far right—all but 331 across the street. (Collection of Bob Stonehill.)

Open Daily Except Sunday
9 A.M. To Midnight
Telephone: SUsquehanna 7-3300

In 1916, the Ansonia installed their Turkish bath and hydrotherapy establishment. This facility was infamously utilized many years later as the Continental Baths and Plato's Retreat, but in its earlier years, men and women maintained separate hours. There was a gymnasium, the latest in obesity treatments, including electric-light cabinets, and a swimming pool with electrically purified water. (Collection of Bob Stonehill.)

William Waldorf Astor (1848–1919), only heir to John Jacob Astor who died in 1890, was a lawyer, politician, minister to Italy, and real estate developer. Although renouncing his United States citizenship after moving to England in 1891, he continued to build in New York City. William had already built the Waldorf Hotel (1893) and the Hotel Astor (1904) before speculating in the West End.

WILLIAM WALDORF ASTOR

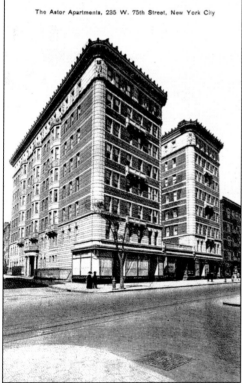

The Astor Apartments, 235 W. 75th Street, New York City

In the listing of plans filed for new structures for 1899 was this trendsetting, eight-story, brick-and-limestone apartment house with stores on the ground floor and an entrance not on Broadway but on West 75th Street. Completed in 1901 for William Waldorf Astor, it was named the Astor Apartments (Clinton and Russell). A 12-story extension was built at West 76th Street in 1913 (Peabody, Wilson and Brown).

61

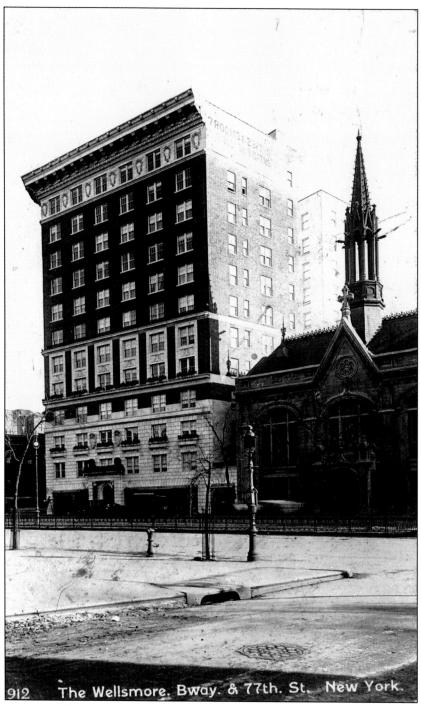

912 The Wellsmore. Bway. & 77th. St. New York.

The firm of Bing and Bing designed the Wellsmore (1910) on the southwest corner of Broadway at West 77th Street. The 12-story apartment house boasted four apartments per floor of seven, eight, or nine rooms with up to three baths; rents were from $1,500 to $3,750 per year. To its south on West 76th Street was the Manhattan Congregational Church (Stoughton and Stoughton, 1901), a seemingly permanent addition to Broadway at the time. (Collection of Bob Stonehill.)

The Stoughton and Stoughton building succumbed to development pressure in 1927 when Rev. Edward H. Emmett announced plans to build a new sanctuary beneath the 23-story Manhattan Towers Hotel (1930, Tillion and Tillion). A limestone Gothic facade was added to the base of the hotel to announce the presence of the church, and ground-floor stores were leased only to businesses that would agree to close on Sunday.

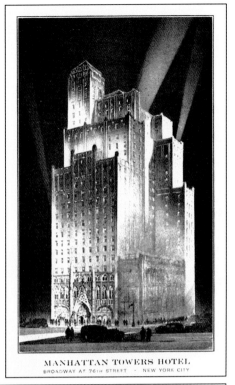

MANHATTAN TOWERS HOTEL
BROADWAY AT 76TH STREET  -  NEW YORK CITY

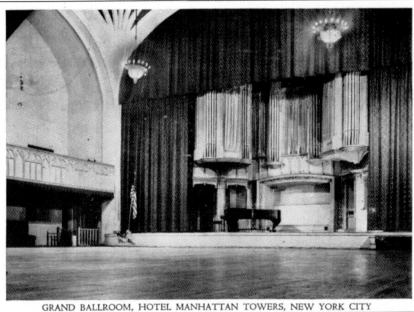

GRAND BALLROOM, HOTEL MANHATTAN TOWERS, NEW YORK CITY

Manhattan Congregational, established in the 1890s, lasted only three years in their 1930s sanctuary and disbanded after financial improprieties surfaced around Reverend Emmett. The Church of Jesus Christ of Latter-Day Saints used the church space until the mid-1940s when it became the ballroom for the hotel. In 1969, this space was rechristened the Promenade, an off-Broadway theater on Broadway. The hotel is now the cooperative apartment building the Opera.

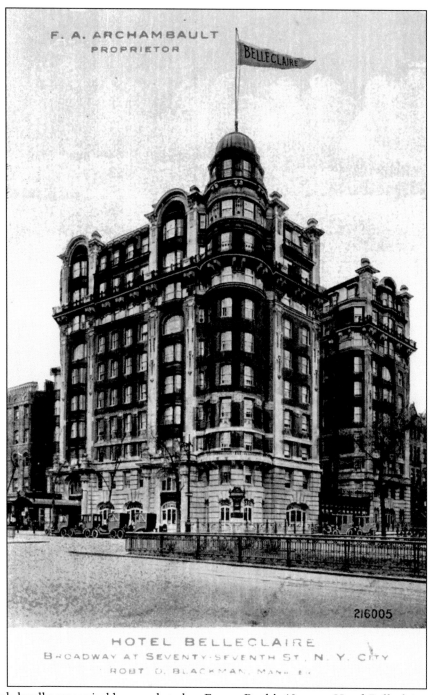

F. A. ARCHAMBAULT
PROPRIETOR

BELLECLAIRE

216005

HOTEL BELLECLAIRE
BROADWAY AT SEVENTY-SEVENTH ST., N. Y. CITY
ROBT. D. BLACKMAN, MANAGER

Though hardly recognizable as such today, Emery Roth's 10-story Hotel Belleclaire (1903) brought the art nouveau and secessionist movements popular in Europe to the Upper West Side together in his treatment of the facade, especially the windows, which were originally 12 pane over 3 pane. The interior was eclectic as well; there was a Flemish-style men's cafe, a mission-style library, and a Moorish-style private dining room. Storefronts have marred the ground floor since the 1920s; the loss of the domed turret has also been devastating.

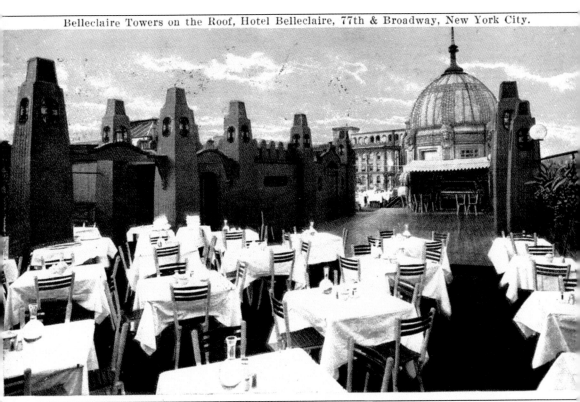

Roof gardens were a popular attraction in the days before air conditioning. Begun as rooftop performance spaces above theaters in the 1880s, they flourished through the 1920s when Prohibition cut their numbers. This makes it a curiosity that the Belleclaire would initiate its Towers on the Roof in 1920. Regardless of Prohibition the Towers caught on; society columns were full of notices of who dined and entertained there and apologies from the Belleclaire to their guests who were turned away at the opening of the season were printed in the *New York Times*. (Collection of Bob Stonehill.)

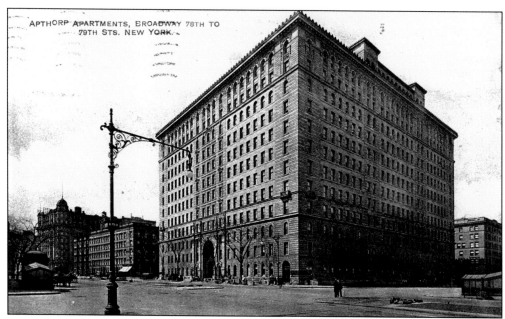

APTHORP APARTMENTS, BROADWAY 78TH TO 79TH STS. NEW YORK.

Creating a private, communal space for apartment dwellers was not easy to do on the Upper West Side, but William Waldorf Astor accomplished it by creating the Apthorp (1908, Clinton and Russell) on a full-block site bounded by Broadway and West End Avenue from West 78th to West 79th Street. The Apthorp was built on the site of the 1759 Vanden Heuvel mansion, later a roadhouse known as Burnham's Hotel.

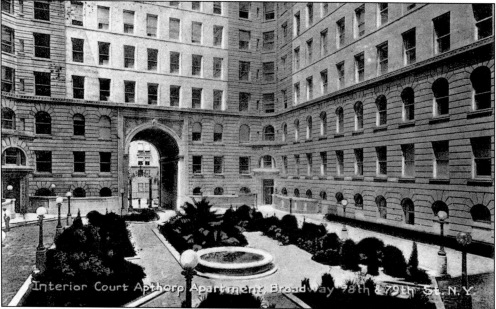

Interior Court Apthorp Apartment Broadway 78th & 79th St. N.Y.

The courtyard in the Apthorp was an enhancement and enlargement of Clinton and Russell's treatment of the eight-story Graham Court (1901), another Astor building, in Harlem. The 12-story Apthorp has two 3-story porte cocheres on Broadway and West End Avenue that lead to a 200-foot-wide courtyard with two fountains, ironwork, marble benches, formal gardens, and in each of the corners, separate elevator lobby entrances.

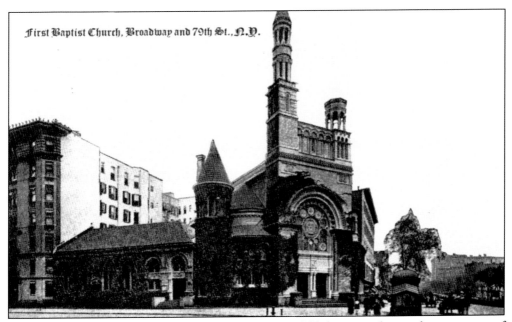

First Baptist Church, Broadway and 79th St., N.Y.

Organized in 1745, the First Baptist Church built its fifth home at the northwest corner of Broadway and West 79th Street from 1890 to 1893. Designed by George Keister, the sanctuary is set at a 45-degree angle to the intersection and features a pair of purposefully asymmetrical towers. In 1902, the church was the only entity to demand that the exit kiosk for the new subway not be placed on their corner.

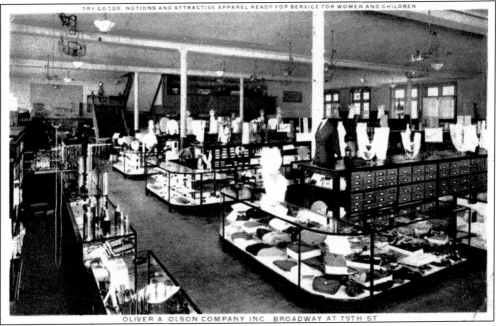

DRY GOODS, NOTIONS AND ATTRACTIVE APPAREL READY FOR SERVICE FOR WOMEN AND CHILDREN

OLIVER A OLSON COMPANY INC. BROADWAY AT 79TH ST

Across Broadway from the First Baptist Church is the two-story commercial building that housed Oliver A. Olson Company's dry goods and notions store (1907, George F. Pelham). In the 1930s, the company filed for bankruptcy, and Woolworth's was quick to pick up the lease on the store. Today Filene's Basement continues the century-long tradition. (Collection of Bob Stonehill.)

On the Boulevard N.Y. Photo Tiemann Co. N.Y.

The earliest real-photo postcard in this book was taken from the Boulevard and West 79th Street looking north around 1895. The buildings on the west side of the Boulevard at West 80th Street were built in 1882 and rebuilt in a mock-Tudor style in the 1920s and named the Calvin Apartments; in 1941, Louis Zabar moved into the third building from West 80th Street. The rest is appetizing history. (Collection of Bob Stonehill.)

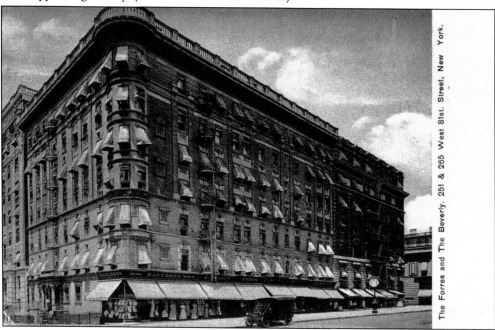

The Forres and The Beverly, 251 & 265 West 81st. Street, New York.

The Forres (1899) at the northwest corner of Broadway and West 81st Street and its neighbor the Saxony (1900, Emery Roth) on the West 82nd Street corner are part of a streetscape that is still easily identifiable in the 21st century. They may have lost their awnings, roofline balustrade, and quaint attempts at fire escapes, but the Forres and Saxony are two first-class survivors.

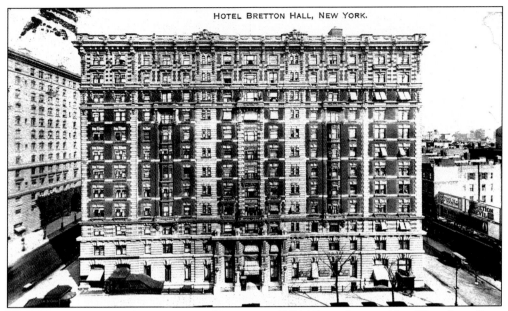

Billed as the largest hotel uptown, Hotel Bretton Hall (1902) on the east side of Broadway from West 85th to West 86th Streets, offered "all the advantages of the best New York City hotels at one-third the price." It was designed by Harry B. Mulliken of Mulliken and Moeller, whose other Upper West Side buildings include the Van Dyck and Severn (page 53), the Jermyn (page 19), and the Chepstow (page 73).

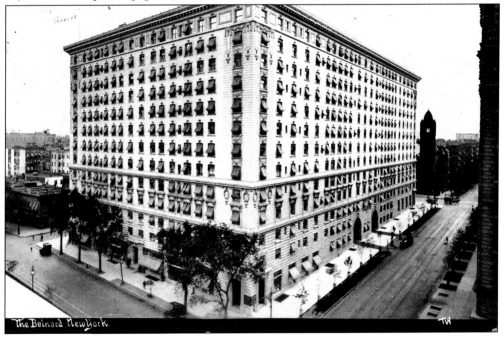

The Belnord New York.

The 12-story Belnord (1909, H. Hobart Weekes) occupies the full block from West 86th to West 87th Streets between Broadway and Amsterdam Avenue. It is a courtyard building where all bedrooms face the interior courtyard, which is a phenomenal 231 feet by 94 feet. At its opening, it contained 175 apartments of from 7 to 11 rooms, not including servant's quarters.

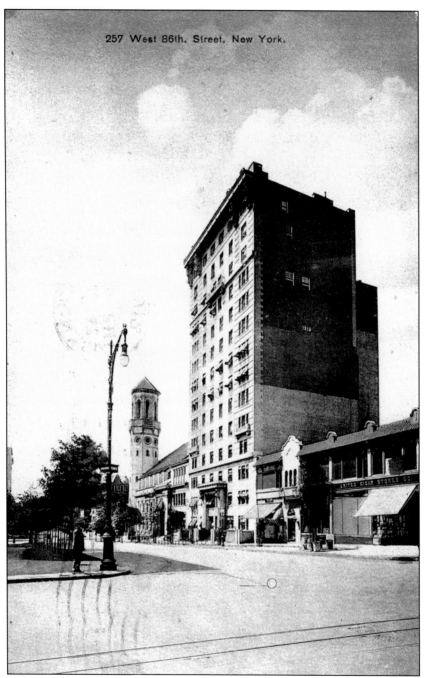

No. 257 West 86th Street (1909, Pollard and Steinem) was the big kid on the block, literally and figuratively. A building that made it into the newspapers for its luminary tenants, which included James T. Shotwell, eminent Columbia historian and exponent of peace, and Rudolph Dirks, creator of the *Katzenjammer Kids*, it also towered over its neighbors, which included the church of St. Paul and St. Andrew (page 104) on West End Avenue and the two-story commercial building in the foreground. This latter structure was replaced in 1989 by the 21-story Boulevard. (Collection of Bob Stonehill.)

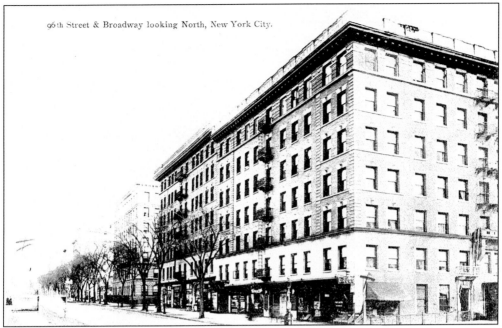

96th Street & Broadway looking North, New York City.

Looking north from West 96th Street on the east side of Broadway are the Wollaston (1900) and the Wilmington (1898); the Powellton (1901) is across West 97th Street. All are seven-story middle-class apartment houses and strangely enough, all are still extant. The Wollaston, closest to the express subway at 96th Street had the prime location, and for many years, the ubiquitous corner drugstore.

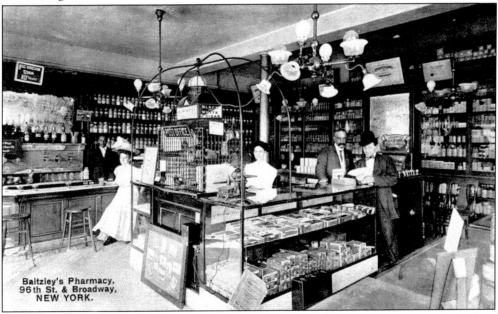

Baltzley's Pharmacy, 96th St. & Broadway, NEW YORK.

Baltzley's Pharmacy dispensed the usual tonics, remedies, and medicines, but they also had an extensive selection of cigars and ice-cream sodas. They were also part of a city-wide scheme in which they rented space to the post office for a neighborhood drop-off station for the local branch. This made it lucrative for Baltzley to publish and sell postcards. (Collection of Bob Stonehill.)

71

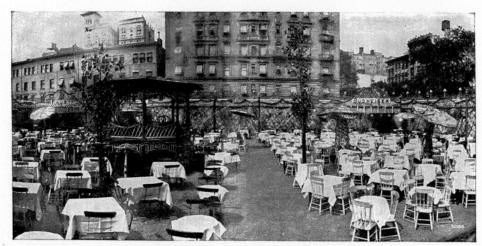

ALFRED NICKEL'S

## UNTER DEN LINDEN
BROADWAY, 97TH TO 98TH ST., NEW YORK CITY
MUSIC 6.30 TO 12 O'CLOCK

SOUVENIR POST CARD CO., N.Y.          ANHEUSER-BUSCH'S CELEBRATED BEERS ON DRAUGHT

The Unter Den Linden roof garden stretched the entire length of Broadway from West 97th to West 98th Streets on two separate two-story buildings. The West 97th Street one, built in 1899, is still extant, while the West 98th Street portion, built in 1913, was replaced by the 14-story 240 West 98th Street (1921, Schwartz and Gross). This view is looking north toward the William's (1900) West 98th Street facade.

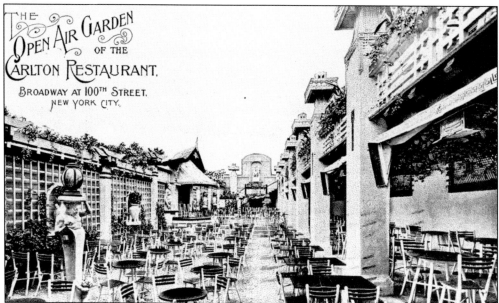

"A Veritable Fairyland in the Heart of the Metropolis" was an apt description for this open-air garden on the roof of the two-story Carlton Terrace Restaurant at the southwest corner of Broadway and West 100th Street. Built in 1911 "with the sky for a roof and the majestic Hudson for a fan," this popular establishment was subsumed into the 15-story Carlton Terrace (now Whitehall) residential hotel in 1923.

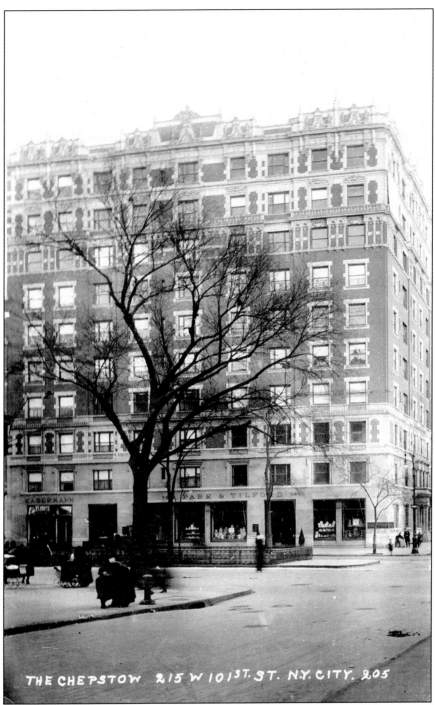

THE CHEPSTOW 215 W 101ˢᵀ ST. N.Y. CITY. 205

Another Mulliken and Moeller stalwart on Broadway is the majestic Chepstow at the northeast corner of West 101st Street. Caught here on a winter morning in 1906, the brand-new Chepstow could boast rents of $1,500 per year on an eight-room, three-bath apartment. It was also rightly proud to be one of seven Manhattan locations of Park and Tilford, the largest retail grocery house in the world, established in 1840.

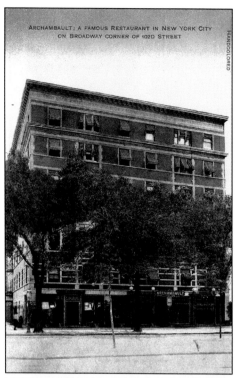

The Kent (1900) on the southwest corner of Broadway at West 102nd Street is a squat, seven-story structure with little to distinguish it except the presence of Archambault's Restaurant and Café. It is now the site of Mama Mexico Restaurant.

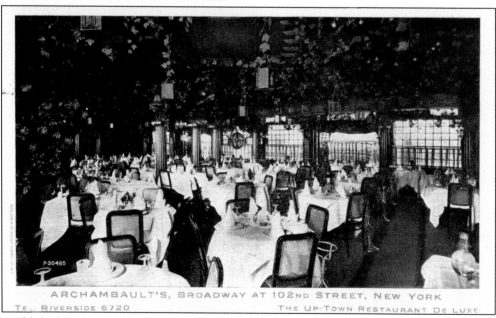

ARCHAMBAULT'S, BROADWAY AT 102ND STREET, NEW YORK
TEL. RIVERSIDE 6720                    THE UP-TOWN RESTAURANT DE LUXE

Established in the Kent in 1900 by Frank A. Archambault, who managed a restaurant in a dry goods store before opening his own restaurant and who seemed forever in and out of bankruptcy court, Archambault's quickly became a popular nightspot. It was bought in 1929 by ousted head of the Child's Restaurant chain, William Childs, who was intent on starting a new chain of restaurants patterned after Old World villages. The one on the Archambault's site was called Old Algiers.

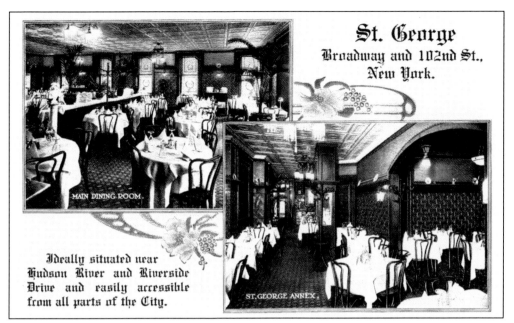

St. George
Broadway and 102nd St.,
New York.

MAIN DINING ROOM.

ST. GEORGE ANNEX.

Ideally situated near Hudson River and Riverside Drive and easily accessible from all parts of the City.

Noted for its excellent cuisine and good service, the St. George prided itself on its homelike atmosphere. Lunch was priced from 40¢; dinner from 60¢. Competition was considerable in the immediate neighborhood as the subway and elevated railroad made this area more accessible to new residents as well as the transients and long-term residents of the many uptown hotels.

The elegant Beaux-Arts Hotel Marseilles on the southwest corner of Broadway and West 103rd Street was built from 1902 to 1905 to designs by Henry Allen Jacobs, a prominent architect of lavish Manhattan town houses and hotels. An 11-story building with furnished and unfurnished suites of one, two, and three rooms, it owed much of its popularity to its proximity to the IRT subway station in the middle of Broadway (at the lower right in this rendering).

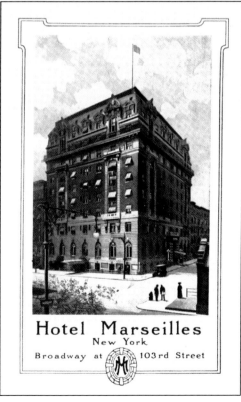

Hotel Marseilles
New York
Broadway at 103rd Street

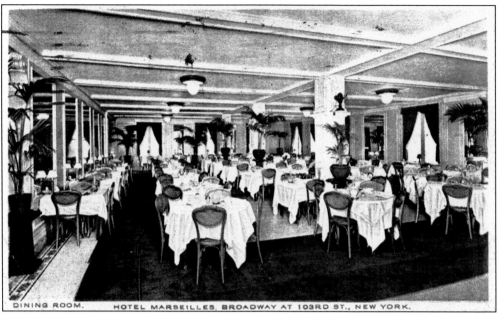

The Hotel Marseilles had private dining rooms, a Palm Court Café entered on Broadway, a cocktail lounge with an elaborate glass skylight, and a full-service restaurant.

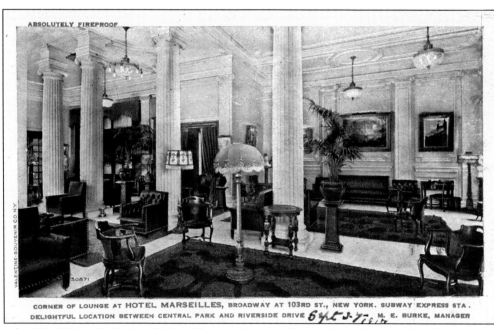

After World War II, the Hotel Marseilles was the most frequently used site in New York for the housing of Holocaust survivors. The lobby, a little more aged than is shown here in 1917, was where families mingled and planned their future in America. The common areas of the hotel were given over to medical and recreation facilities, English-language classrooms, and clothing distribution centers.

*Four*

# COLUMBUS AVENUE

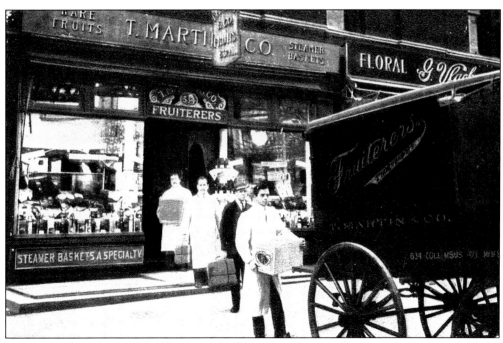

At a time when the arrival of fruits made the grocery notes column in the *New York Times*, fruiterers distributed delicacies from such exotic locales as California, Florida, France, and South Africa. T. Martin and Company, of 534 Columbus Avenue off West 86th Street, specialized in steamer baskets. Delivered to steamship passengers prior to voyage, these baskets typically contained ginger, dates, figs, apples, pears, oranges, kumquats, tangerines, chocolates, and salted nuts. (Collection of Bob Stonehill.)

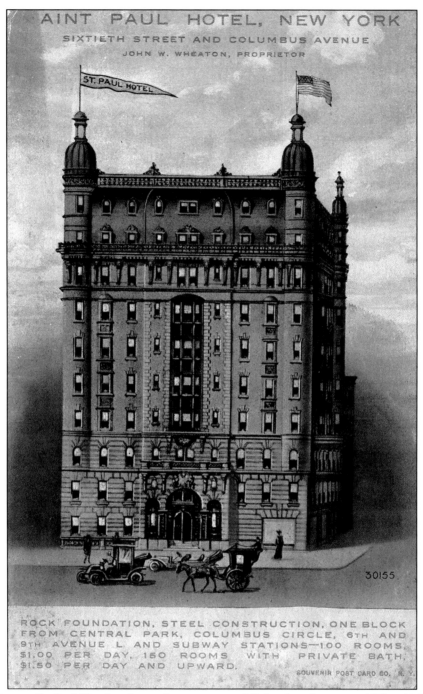

The 10-story St. Paul Hotel at the southwest corner of Columbus Avenue and West 60th Street advertised rooms at popular prices—over 200 rooms at $1.50 per day in 1904. It was located across Columbus Avenue from the Church of St. Paul the Apostle, the home of the Paulist Fathers and the largest noncathedral church in the world at the time of its dedication in 1885. The hotel was replaced in 1957, part of the Columbus Circle Title I Slum Clearance, with the Coliseum Park Apartments (Sylvan and Robert Bien), a vast 15-story, brown brick apartment house.

Hotel Hargrave (Frederick C. Browne), a refined family and transient hotel, with single rooms especially furnished for bachelors, opened in 1902 on West 72nd Street just west of Columbus Avenue. The Park and Tilford Building (1892, McKim, Mead and White) is to its left as is the platform of the 72nd Street station of the Ninth Avenue Elevated. The town houses to the right have since been razed for apartment houses.

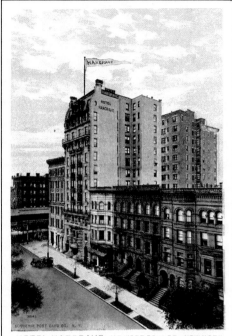

HOTEL HARGRAVE, 112 WEST 72ND ST., NEW YORK

NEW YORK'S MOST ACCESSIBLE HOTEL, SIX LINES OF TRANSIT, INCLUDING ELEVATED AND SUBWAY EXPRESS STATIONS ON BLOCK. LOCATED BETWEEN CENTRAL PARK WEST AND RIVERSIDE DRIVE. 300 ROOMS, 200 BATH ROOMS. EUROPEAN PLAN, $2.00 PER DAY AND UP.

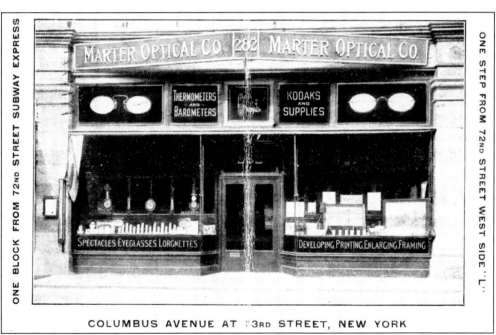

Just steps from the Ninth Avenue Elevated exit at West 73rd Street was the Marter Optical Company. Occupying a still extant Henry Hardenbergh–designed building begun in 1879, a year before his Dakota, Marter's specialized in eyeglasses, spectacles, and lorgnettes (opera glasses) as well as developing photographs and selling cameras.

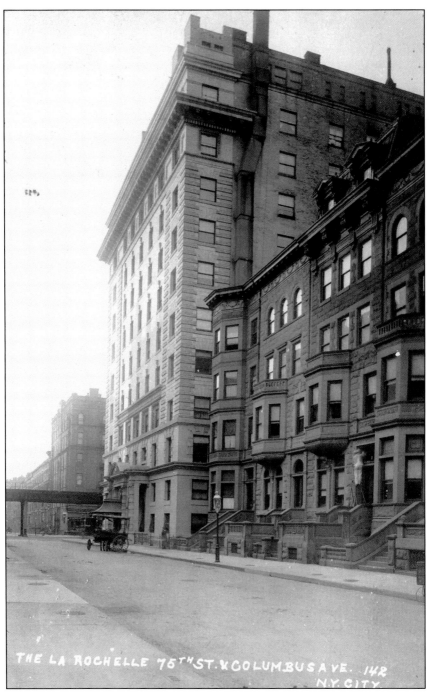

THE LA ROCHELLE 75TH ST. & COLUMBUS AVE. 142
N.Y. CITY

Still prominent among lower Columbus Avenue, La Rochelle (1896, Lamb and Rich) stands tall among the town houses and small apartment buildings at the northeast corner of West 75th Street in this 1905 view. Originally occupied by 40 families, each in seven very large rooms, with a prestigious restaurant below (page 9), rents ranged from $1,200 to $1,900 per year. All the buildings in this image are still extant, including the Lawrence (1890, Ogden and Son) directly behind the elevated trestle. (Collection of Bob Stonehill.)

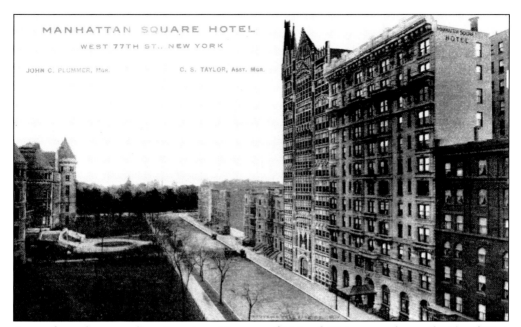

Across from the expanding American Museum of Natural History on the south side of West 77th Street the high-class family apartment Manhattan Square Hotel (George F. Pelham) opened in 1903. To the east at No. 44, Harde and Short created a gothic marvel whose facade abounded in crockets, finials, trefoils, quatrefoils, and pinnacles, all done in terra-cotta, much of which has not survived. Completed in 1909, it was one of the earliest cooperative ventures in the city.

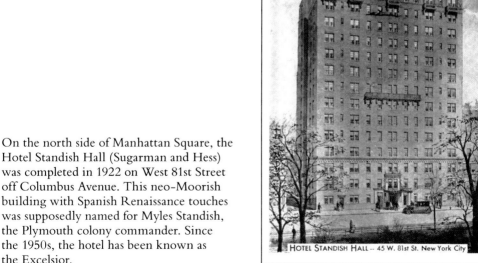

On the north side of Manhattan Square, the Hotel Standish Hall (Sugarman and Hess) was completed in 1922 on West 81st Street off Columbus Avenue. This neo-Moorish building with Spanish Renaissance touches was supposedly named for Myles Standish, the Plymouth colony commander. Since the 1950s, the hotel has been known as the Excelsior.

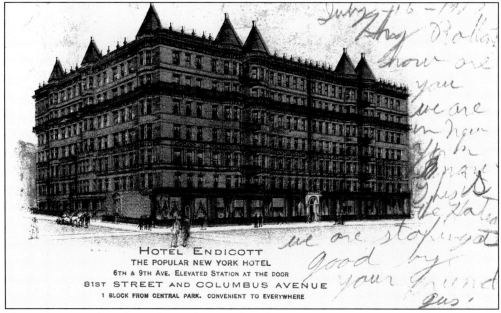

Planned as a rival to the Dakota, the Hotel Endicott (1891, Edward L. Angell) is actually two separate seven-story redbrick–and-stone buildings with terra-cotta trim, surrounding a central light court. It occupies the west side of Columbus Avenue from West 81st to West 82nd Streets. This rendering conveniently neglects the elevated platforms of the 81st Street station, which would have run past the third floor windows and thrown a pall over the storefronts.

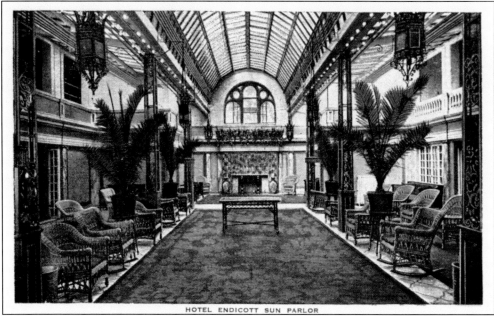

HOTEL ENDICOTT SUN PARLOR

The central light court was used to great advantage as a sun parlor and palm garden with ever-changing decor—as fashions changed, so did the furniture, rugs, and lighting. Regardless of this elaborate "outdoor" space, the hotel advertised itself as the "most Homelike Hotel in the City."

82

Charles Coolidge Haight (1841–1917) was an architect whose most important works in New York City include the midtown campus of Columbia College (no longer extant) and the General Theological Seminary in Chelsea. On the Upper West Side, he designed Christ Church (page 51), the New York Cancer Hospital (page 44), and St. Ignatius of Antioch Episcopal Church (page 105).

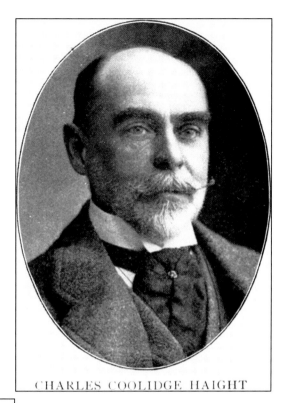

CHARLES COOLIDGE HAIGHT

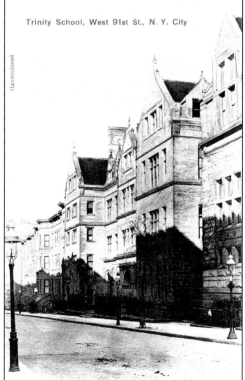

Trinity School, West 91st St., N. Y. City

Handcolored

Haight was also given the commission for the West 91st Street relocation of the Trinity School, the oldest continuously operated school in the city. Founded in 1709 by the Venerable Society for the Propagation of the Gospel in Foreign Parts, the school held its first classes in the tower of Trinity Church. It moved to the West End in 1895.

83

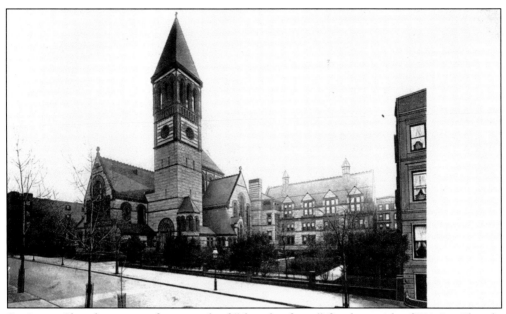

St. Agnes Chapel was one of a network of "chapels of ease" for the parish of Trinity Church. Designed by William A. Potter, half-brother of the Episcopal Bishop of New York, Henry Codman Potter (page 118), it was built between 1890 and 1892 from West 91st to West 92nd Streets on a mid-block location between Columbus Avenue and Amsterdam Avenue. This is the view southeast along West 92nd Street.

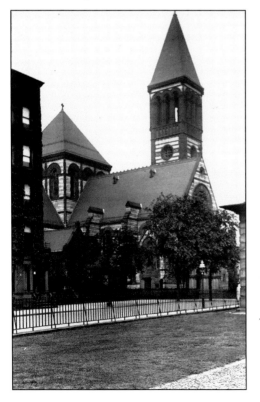

In this view, the campanile, or bell tower, and cimborio, the central crossing tower, are placed in contrast to the town house on West 92nd Street off Columbus Avenue. On occasion of the chapel's first service on June 5, 1892, the *New York Times* expressed, "St. Agnes is not only the finest church edifice under the jurisdiction of Trinity Parish, but the finest church structure, barring the cathedral [St. Patrick's], in New-York City."

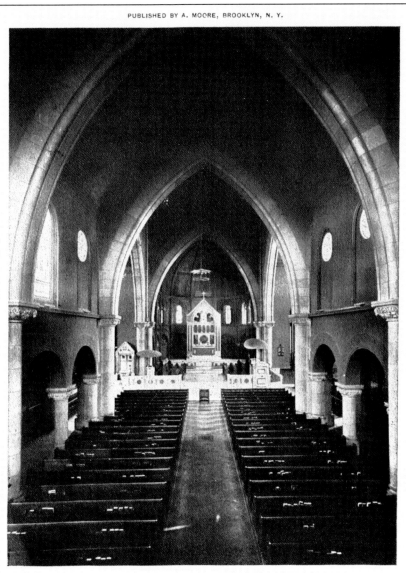

ST. AGNES CHAPEL (TRINITY PARISH)
WEST 92ND ST., NEW YORK

The triple-arched entrance facade on West 92nd Street led congregants to a large vestibule and then to the wide central aisle and the narrow side aisles of this cruciform chapel. Large transverse arches spanned the nave; "their great size and extreme simplicity give an effect of great dignity to the interior," according to the 1892 Trinity Parish yearbook. Beyond this was a deep apsidal choir. There was also a Morning Chapel located off to the right of the nave below the west transept.

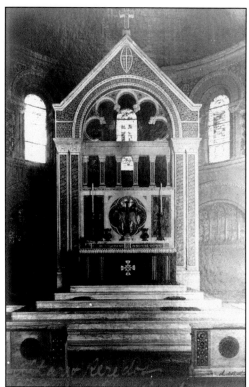

Located in the apsidal choir, the high altar was reached by a flight of seven stairs and framed by a reredos, or partition wall, over 35 feet high. Both the altar and reredos were made of marble and inlaid with polished marble panels and glass mosaics. The stained-glass windows behind these were carried out under the direction of Tiffany Glass Company; the domed ceiling above was lacquered gold.

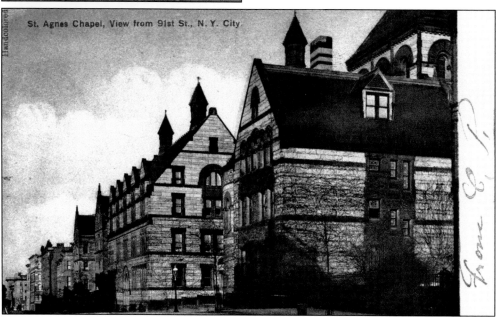

St. Agnes Chapel, View from 91st St., N. Y. City

As a result of demographic changes on the Upper West Side, a declining congregation, financial hardship, and the opportunity for expansion of the Trinity School located next door (page 83), the chapel was closed and demolished in 1944 for a playing field. The rectory, in the foreground, was also demolished. The parish house, to the left of center, is still extant. This view is looking northwest along West 91st Street.

*Five*

# AMSTERDAM AVENUE

In marked contrast to St. Agnes Chapel, the Church of Eternal Hope on West 81st Street between Amsterdam and Columbus Avenues conforms quite well to the street grid by building to the lot line and having only a shallow setback. The church was built for the Third Universalist Society, established in 1834, which occupied it from 1893 to 1910. In the time since, the sanctuary has been of service to Jews, Latter-Day Saints, and Baptists.

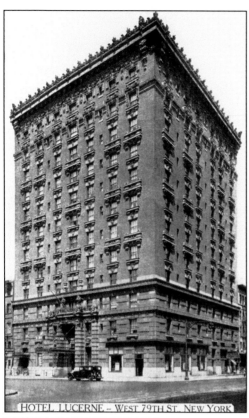

Since 1904, the Hotel Lucerne (Harry B. Mulliken) has stood on the northwest corner of Amsterdam Avenue and West 79th Street weathering the changes in style, fashion, and clientele, while keeping up its distinctive, highly detailed facade of plum-colored brownstone. The hotel boasted an attractive grill and dining room, specialty shops, and views overlooking the Hudson River and Central Park.

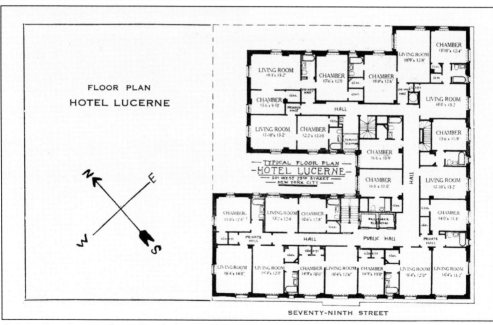

Originally advertised as a family hotel where good references were required, the Lucerne was designed with 130 choice suites of one to six rooms and baths. This is a typical floor plan from an advertising postcard from the 1920s.

Rev. Dr. Anson Phelps Atterbury (1855–1931) was the pastor of Park Presbyterian Church for 32 years until the church merged with the West Presbyterian Church, originally located near Bryant Park, in 1911. Atterbury continued as copastor until 1918, when he became pastor emeritus and served as president of the New York Society for the Suppression of Vice.

REV. ANSON PHELPS ATTERBURY, D.D.

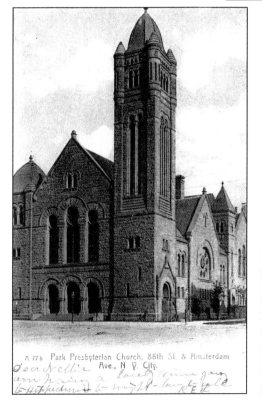

A 77b Park Presbyterian Church, 86th St. & Amsterdam Ave., N. Y. City.

Reverend Dr. Atterbury was instrumental in moving his congregation to the northeast corner of Amsterdam Avenue and West 86th Street, first to a large chapel designed by Leopold Eidlitz in the early 1880s, seen here on the far right. By 1890, the main sanctuary on the corner was completed to designs by Henry F. Kilburn in a style congruent with the earlier chapel. The postmark on this card is 1906, five years before the merger.

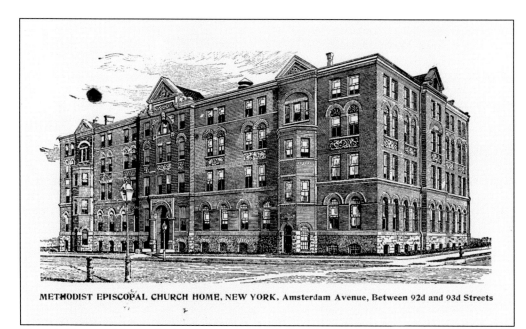

METHODIST EPISCOPAL CHURCH HOME, NEW YORK, Amsterdam Avenue, Between 92d and 93d Streets

The third home of the Methodist Episcopal Church Home (1885, D. and J. Jardine), established in 1850, occupied the eastern side of Amsterdam Avenue from West 92nd to West 93rd Street, directly across the avenue from the West Side Tennis Club. The home moved to Riverdale in 1929, and the building laid vacant until 1940 when it was razed for a pair of six-story apartment houses.

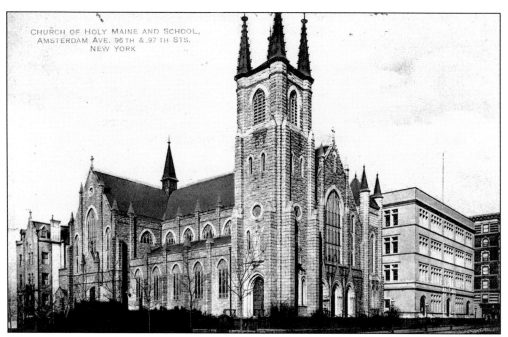

CHURCH OF HOLY MAINE AND SCHOOL, AMSTERDAM AVE. 96TH & 97TH STS. NEW YORK

Contrary to the caption on the postcard, this is the Church of the Holy Name of Jesus. This is the second home of this Roman Catholic church built from 1891 to 1900 at the northwest corner of Amsterdam Avenue and West 96th Street to the designs of Thomas Henry Poole. A steeple was added in 1918. The Holy Name School on West 97th Street was built in 1905.

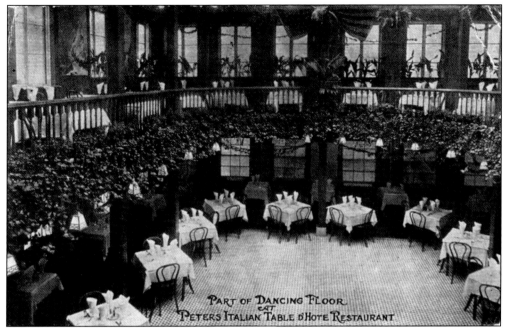

PART OF DANCING FLOOR
AT
PETERS ITALIAN TABLE D'HOTE RESTAURANT

These images are of the dining room and dance floor of the restaurant at 163 West 97th Street between Amsterdam and Columbus Avenues. The view above is of Peter's Italian Table D'Hote Restaurant around 1910; the view below is of Will Oakland's Chateau Shanley in the 1920s. Will Oakland was a famous balladeer and nightclub owner who also operated the Terrace, Hunter Island Inn, and Willow Club. The restaurant was razed in the 1950s as part of a larger slum-clearance effort, and Public School 163, the Alfred E. Smith School, replaced it.

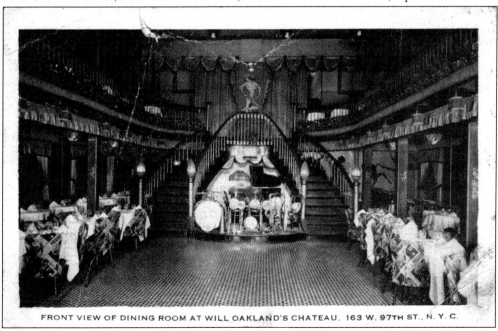

FRONT VIEW OF DINING ROOM AT WILL OAKLAND'S CHATEAU. 163 W. 97TH ST., N. Y. C.

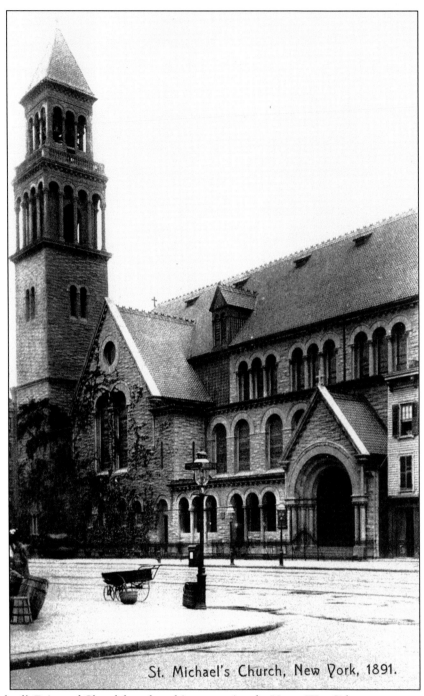

St. Michael's Church, New York, 1891.

St. Michael's Episcopal Church has a long history serving the Upper West Side—over two centuries on the same site. The original plain white frame church was built in 1807 when the area was the village of Bloomingdale; the second church, built of oak in the Gothic manner, was consecrated in 1854. The present church was consecrated in 1891 and stands on the west side of Amsterdam Avenue from West 99th to (almost) West 100th Street. Its unconventional design with an entrance on the east side of the nave on Amsterdam Avenue was by Robert W. Gibson.

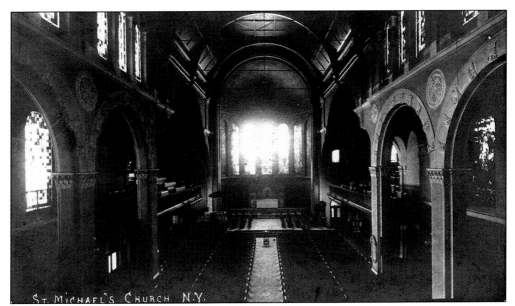

The interior of the church, painted originally in neutral colors, was dramatically offset by the colors of the altar mosaic, altar rails, reredos, apse dome, and stained-glass windows created by Tiffany Studios. Seven of these windows have graced the apse since 1895, known as "St. Michael's Victory in Heaven." The church boasts one of the largest intact Tiffany installations in its original setting.

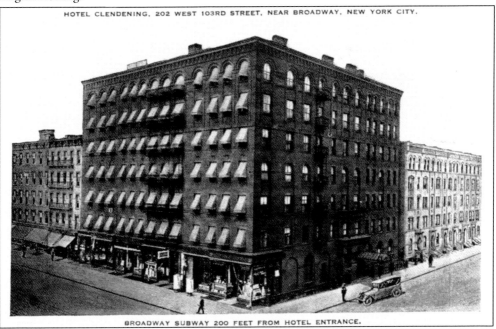

The area around Amsterdam Avenue and West 103rd Street was once known as Clendening Valley after one of the "merchant princes" of the city, John "Lord" Clendening, who made a fortune importing Irish textiles. The hotel that bore his name was located on the southwest corner of that intersection, where his mansion was located, until the Frederick Douglas Houses Addition was built in 1965.

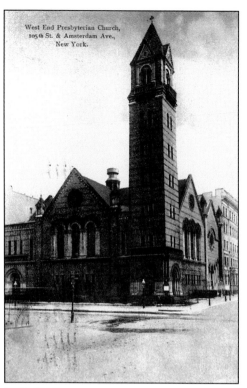

West End Presbyterian, a cheerful yellow-brick church with an enormous tower at the northeast corner of Amsterdam Avenue and West 105th Street, was built in 1891 to the designs of Henry F. Kilburn, who also designed West Park Presbyterian (page 89). An earlier chapel, seen to the right of the main sanctuary, was replaced in 1913 by the present parish house.

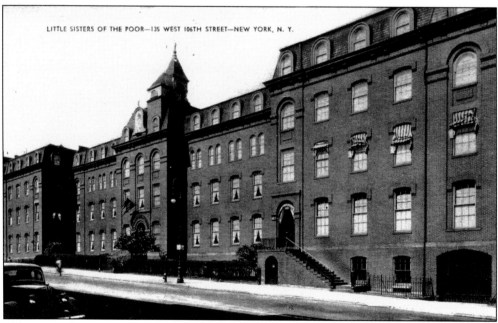

This massive home, for elderly men and women with few resources except good morals, was built from 1884 to 1887 on the northern side of West 106th Street between Amsterdam and Columbus Avenues. Operated by the Little Sisters of the Poor, a Roman Catholic sisterhood organized in France in 1836, it was one of their several New York homes. The Red Oak Apartments, a federally run senior citizen center replaced it in the 1970s. (Collection of Bob Stonehill.)

# Six

# WEST END AVENUE

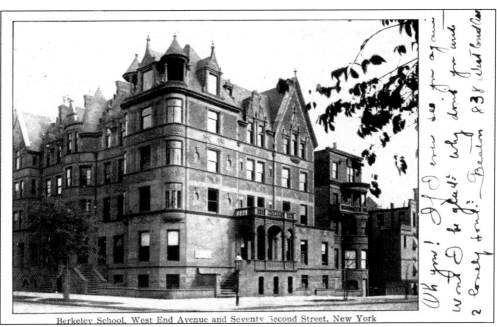

Berkeley School, West End Avenue and Seventy Second Street, New York

Located at the southeast corner of West End Avenue and West 72nd Street, the Columbia Institute was a primary, intermediate, and college preparatory school, with an optional military drill. In 1905, the older Berkeley School, renowned for preparing pupils for Harvard, Yale, Columbia, and Princeton, moved here and consolidated with the Columbia Institute. The school was razed for the apartment house at 260 West End Avenue (1925, Schwartz and Gross). (Collection of Bob Stonehill.)

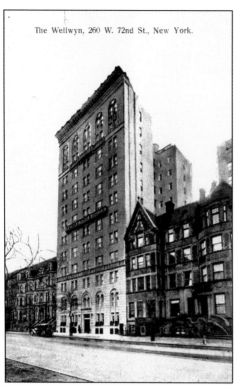

The Wellwyn, 260 W. 72nd St., New York.

In 1912, the Wellwyn heralded the changing character of West 72nd Street from a private residential thoroughfare to an apartment house and commercial corridor. The *New York Times* claimed it was the second apartment house built west of Broadway on the Upper West Side, after the Chatsworth on Riverside Drive (page 110). The rest of the block also succumbed to this type of development, except for three of the town houses to the left.

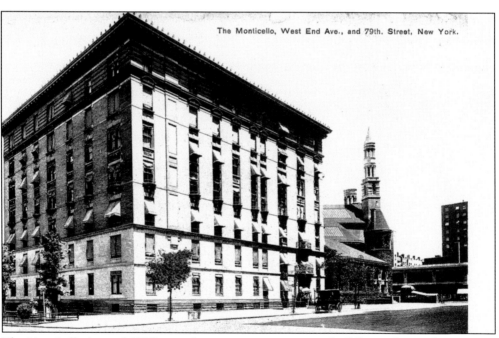

The Monticello, West End Ave., and 79th. Street, New York.

The Monticello (around 1895), a modest seven-story apartment building at the northeast corner of West End Avenue and West 79th Street, stands next to the First Baptist Church on Broadway. The Hotel Lucerne is off to the far right. The Monticello was replaced by 400 West End Avenue (1930, Margon and Holder), where Joe DiMaggio lived in the 1940s.

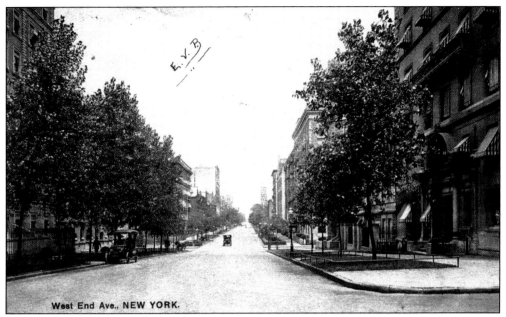

West End Ave., NEW YORK.

West End Avenue, seen here looking north from West 80th Street, had been intended by early planners to be a commercial street with shops and small businesses serving the private residences of Riverside Drive; it became a solidly middle-class avenue of apartment residences and churches. This view shows the first wave of development, which, with few exceptions, was obliterated within a generation or two.

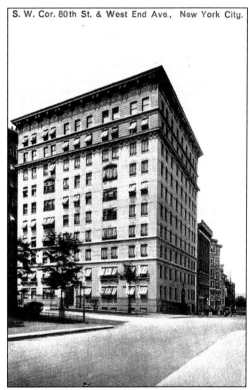

S. W. Cor. 80th St. & West End Ave., New York City.

This 10-story apartment house on the southwest corner of West 80th Street, although much more substantial than the Monticello across the way, suffered the same fate. In 1936, it was razed for the art deco 411 West End Avenue (George F. Pelham II).

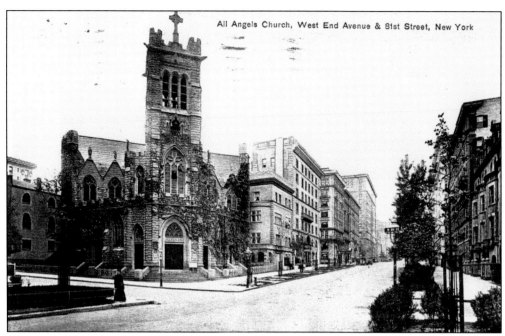

All Angels Church was established in the 1830s as a mission to the African American, German, and Irish poor of Seneca Village (located in what would become Central Park) by St. Michael's Episcopal Church (page 92). In 1890, this Gothic sanctuary, the third home of the church, was built on the southwest corner of West 81st Street and West End Avenue.

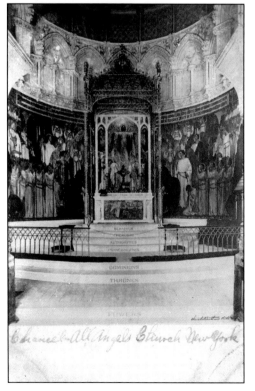

The congregation of All Angels Church grew in the early decades of the 20th century, and the church became quite popular for its choir and its radio broadcast services. Above the mosaic altar was a gilded baldachin, or canopy, which was illuminated. Other treasures included a two-and-a-half-story Tiffany window and a pulpit with limestone angels surmounted by a large wood-sculpted angel trumpeting out to the congregation.

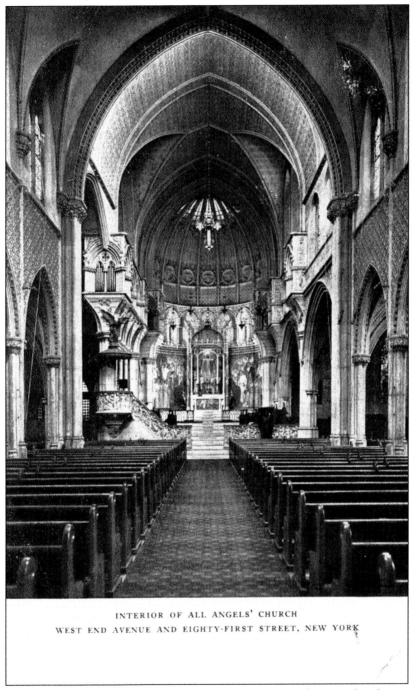

All Angels Church was designed in a cruciform manner by Samuel B. Snook, who ingeniously created a 140-foot sanctuary along the diagonal of the 100-by-102-foot plot. Above the sanctuary hung a Celtic cross–shaped lamp brought from Venice. Dwindling congregation and development pressure led to the demolition of this glorious structure in 1979; West River House, a 21-story apartment tower built in 1983, has taken its place. The congregation now meets in the Parish House (1904, Henry J. Hardenbergh) on West 80th Street.

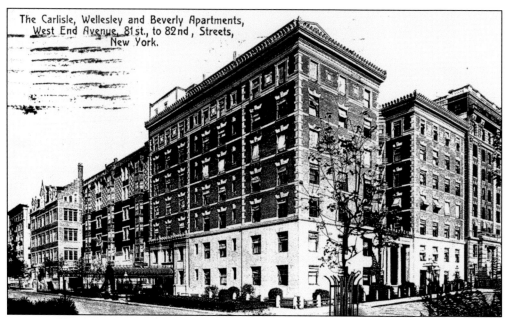

The Carlisle, Wellesley and Beverly Apartments, West End Avenue, 81st, to 82nd, Streets, New York.

Opposite All Angels Church on the northeast corner of West End Avenue and West 81st Street was the Wellesley Apartments and to its north the Carlisle. Both were built prior to 1897 and razed only 30 years later for 440 and 450 West End Avenue designed by George F. Pelham, a prolific New York City apartment house designer, especially on Morningside Heights. The Beverley, on the far right, is still extant.

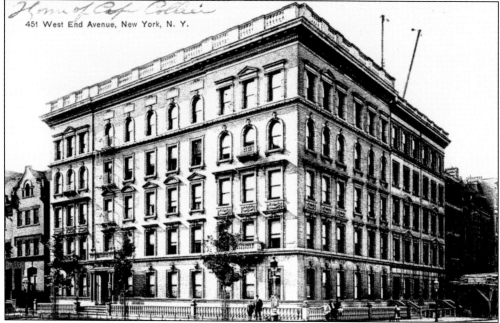

451 West End Avenue, New York, N. Y.

No. 451 West End Avenue was an elegant pre-1897 flats building that was actually comprised of four separate dwellings; the southwest corner building on West 82nd Street and West End Avenue was the largest. The entire block from West 81st to West 82nd Streets was redeveloped in 1926 as 441–451 West End Avenue (George F. Pelham). (Collection of Bob Stonehill.)

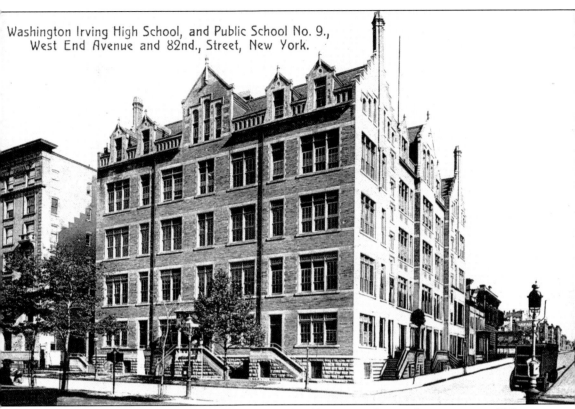

Washington Irving High School, and Public School No. 9.,
West End Avenue and 82nd., Street, New York.

Grammar School No. 9 began in a wooden schoolhouse on the northeast corner of West 82nd Street and West End Avenue in the mid-1800s. By 1880, a brick structure had taken its place, and in 1895, the current school was built to the designs of C. B. J. Snyder, the board of education's superintendent of buildings. Now known as Public School M811, for students with multiple disabilities, it was named the Mickey Mantle (1931–1995) School in 2002 after the New York Yankee hall of famer.

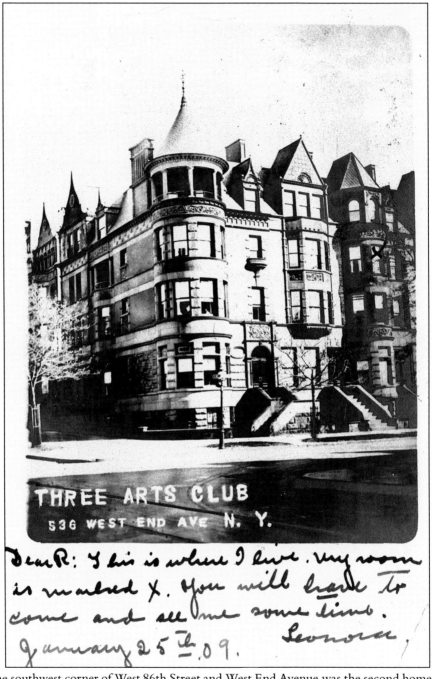

THREE ARTS CLUB
536 WEST END AVE N. Y.

*Dear R: This is where I live. my room is marked X. You will have to come and see me some time.
January 25th 09.    Leonora,*

On the southwest corner of West 86th Street and West End Avenue was the second home of the Three Arts Club, occupied from 1908. Modeled after the American Girls Club of Paris in 1902, the club brought together young women who flocked to New York to pursue painting, music, or the dramatic arts. It provided the "spirit of a real home life, and freedom" from the many restrictions imposed upon the "inmates" of other boardinghouses. The club moved to 338 and 340 West 85th Street in 1910 and finally disbanded in 1952. No. 530 West End Avenue (1912, Mulliken and Moeller) replaced these town houses.

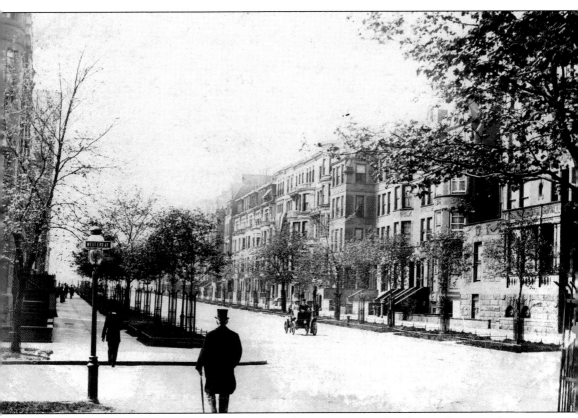

This view is a bit of a mystery. One can see from the street marker that the gentleman in the top hat is crossing West End Avenue, presumably at the start of the 20th century. From an exhaustive study of the fire insurance maps of the day, this appears to be West 86th Street looking northwest toward Riverside Drive. In which case, all of these town houses have since been obliterated for a formidable wall of luxury apartment houses. (Collection of Bob Stonehill.)

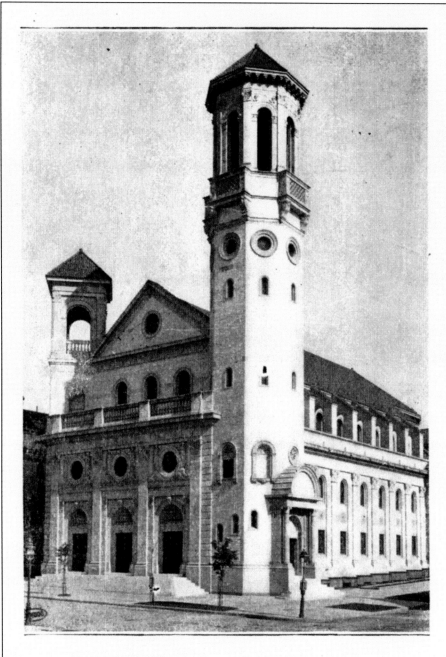

ST. PAUL'S METHODIST EPISCOPAL CHURCH
West End Ave. & 86th St., New York

Across the street from the scenes on the prior two pages stands the third home of St. Paul's Methodist Episcopal Church (1897, R. H. Robertson) on the northwest corner of West 86th Street and West End Avenue. Founded in 1834, it merged over a century later in 1937 with St. Andrew's Methodist Episcopal Church, organized in 1875. Today the church is in need of much restoration after having been denied permission to raze its sanctuary due to its landmark status.

The Episcopal Church of St. Ignatius of Antioch (1892, Charles C. Haight) is next door to St. Paul's Methodist Episcopal Church, at the southeast corner of West 87th Street and West End Avenue. The Episcopal Church of St. Ignatius of Antioch was formed in a split between the Low and High Church within the Episcopalian faith in 1871; this sanctuary, with interiors by Ralph Adams Cram, is its second home.

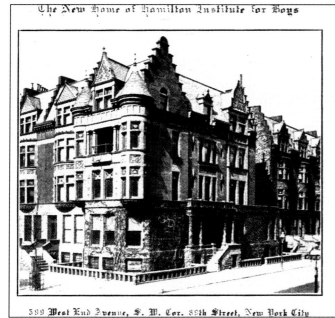

The Hamilton Institute for Boys was established in 1891 on West 81st Street, north of Manhattan Square. The institute prepared young men for college and business careers. In 1911, the institute moved to the southwest corner of West 89th Street and West End Avenue and remained there until the 1920s, when it was replaced by the narrow 12-story 599 West End Avenue (1924, George and Edward Blum). (Collection of Bob Stonehill.)

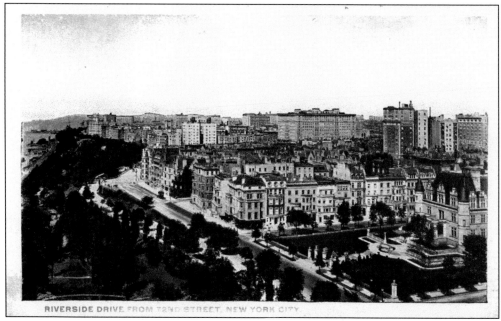

RIVERSIDE DRIVE FROM 72ND STREET, NEW YORK CITY.

A picturesque parkway curving up the West End from West 72nd Street, Riverside Drive was imagined as the new Fifth Avenue, where sumptuous mansions would dominate the landscaping along Riverside Park. As seen here in 1910, the Charles M. Schwab mansion (page 107) was the largest and most expensive of the private houses to be built.

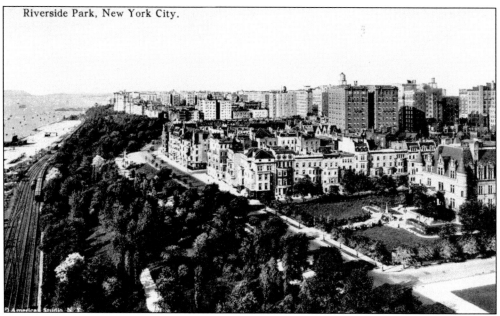

Riverside Park, New York City.

Several years later, the town houses that came to dominate the earlier view were already giving way to developers. Apartment houses were starting to encroach on the blocks of the Upper West Side between West End Avenue and Riverside Drive by 1910, and that pace would accelerate in the 1920s. Fortunately most of the town houses to the north of the Schwab mansion on West 74th Street designed by C. P. H. Gilbert (1895–1897) are extant.

## *Seven*

# RIVERSIDE DRIVE

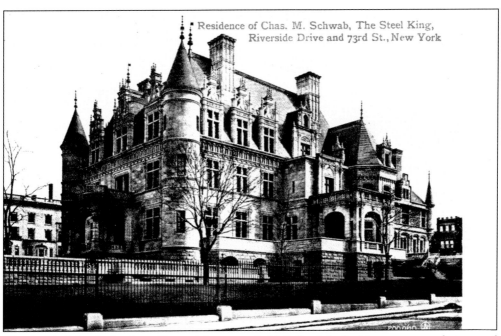

Residence of Chas. M. Schwab, The Steel King, Riverside Drive and 73rd St., New York

Charles M. Schwab, Andrew Carnegie's partner in U.S. Steel, built this sumptuous chateau and grounds on the entire block bounded by Riverside Drive and West End Avenue from West 73rd to West 74th Street. Built to the designs of Maurice Hebert from 1901 to 1907, it cost $6 million and replaced the Orphan Asylum Society home that was on the site since the early 1800s. The mansion stood empty from 1929 to 1948, when it was razed for the full-block, 16-story, 630-family Schwab House (1950, Sylvan Bien).

This double-wide postcard shows Riverside Drive north of its origin at West 72nd Street in 1915. The buildings from right to left are One, Three, and Four Riverside Drive. The latter has been replaced by Five Riverside Drive, a 17-story apartment building at the corner of West 73rd Street. The site between One and Three is now home to an incongruous six-story

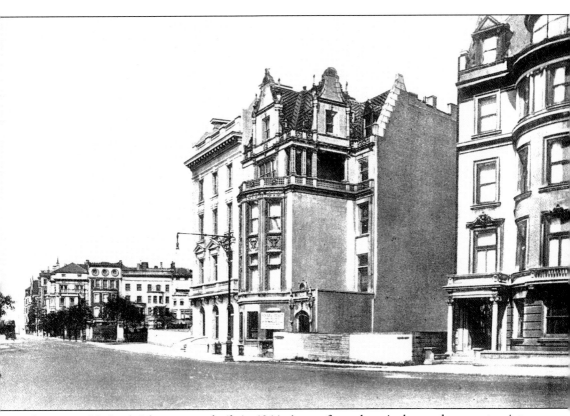

brown-and-beige brick tenement built in 1964. Across from these is the southernmost point of Riverside Park, site of the statue of Eleanor Roosevelt by Penelope Jencks, which has been sitting there contemplating since 1996.

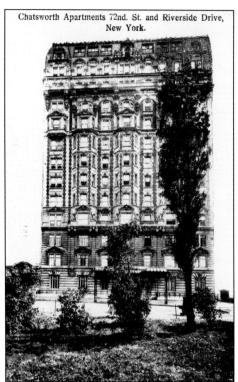

Chatsworth Apartments 72nd. St. and Riverside Drive, New York.

The Chatsworth (John E. Scharsmith) has stood to the west of Riverside Drive on West 72nd Street since 1904. Actually two buildings, one on West 71st Street, that share a common entry, it was designed with luxury housekeeping apartments. An annex was built to the east in 1906, entered by a one-story pavilion seen to the left of the main building.

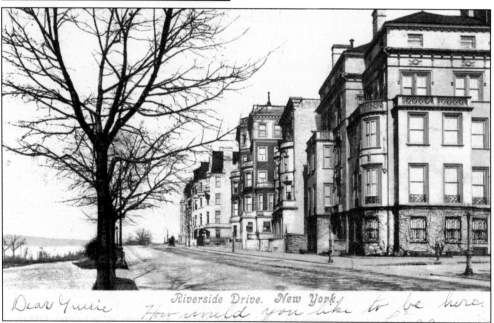

*Riverside Drive. New York.*

Looking north along Riverside Drive are the town houses built by C. P. H. Gilbert (1895–1897) from West 74th to West 75th Streets and those of Lamb and Rich to West 76th Street. Several of these, including that in the foreground, built for George H. Macy, a tea importer, have been demolished and replaced by apartment buildings, the Macy town house by the 20-story 22 Riverside Drive (1931, William Paris).

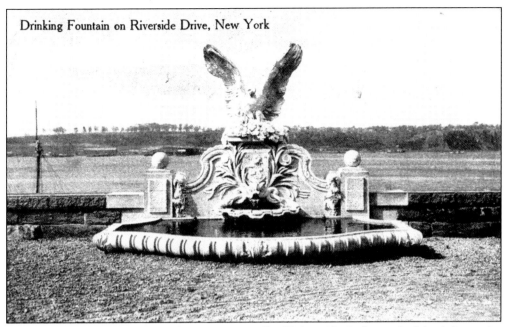

Drinking Fountain on Riverside Drive, New York

Opposite West 76th Street on the retaining wall of Riverside Park stands this pink granite fountain (1906, Warren and Wetmore) given to the city by Robert Ray Hamilton, a wealthy politician and sportsman who died on a hunting trip in 1890. The unspoiled Palisades on the New Jersey side of the Hudson River are still visible in this 1914 view.

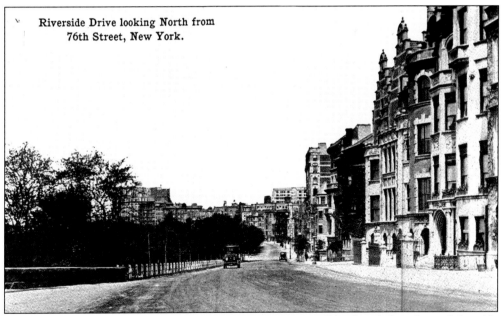

Riverside Drive looking North from 76th Street, New York.

Town houses from the late 19th and early 20th century can still be found along lower Riverside Drive. In fact, an entire block of town houses is still extant from West 76th to West 77th Street, most of them designed and built by Clarence True from 1896 to 1897. Part of the West End–Collegiate Historic District, they include the four-and-a-half story, twin-gabled corner building with three-story curved bay at 46 Riverside Drive.

The Hudsonia, 315–321 West 79th Street, New York City

The north side of West 79th Street from Riverside Drive to West End Avenue featured the Hudsonia (1902), adjacent to a town house on the northeast corner of Riverside Drive, Lasanno Court (1902) to its east, and the New Century (1900) on the northwest corner of West End Avenue. The New Century survives in a much-altered form; its automobile garages are now the site of the Carlebach Shul. Lasanno Court is now the Imperial Court Hotel. No. 70 Riverside Drive, a 55-family apartment house of six and seven stories with parking garage, replaced the Hudsonia (and the corner town house) in 1951. (Collection of Bob Stonehill.)

This town house on the southeastern corner of Riverside Drive and West 80th Street was the home of the Clark School for Concentration in the 1920s. A successful college preparatory school where boarding and day pupils were tutored for a summer, semester, or year in a wide range of academic subjects, they also offered a series of 10 lectures on applied concentration for professionals and businessmen. It may be hard to believe, but this location housed the chemistry laboratories, where an explosion killed a 17-year-old student in 1923. It is now a multiple family dwelling.

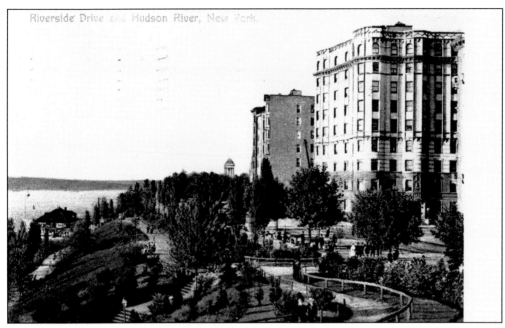

Across from this entrance to a meticulously landscaped Riverside Park stands 120 Riverside Drive on the northeast corner of West 84th Street. A wonderfully undulating castle of steel, granite, limestone, and brick, it was built in 1906 and claimed to be the only fireproof building on Riverside Drive between West 72nd and West 92nd Streets. The building still enchants, though alterations to the roofline and the addition of fire escapes do detract a little.

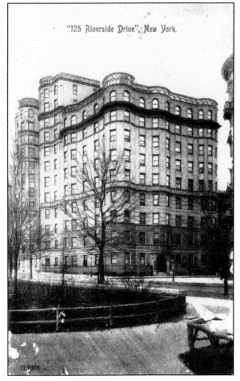

"125 Riverside Drive", New York.

In 1908, a slightly taller annex was built to the north of 120 and together they were renamed 125 Riverside Drive. Apartments were originally from 8 to 12 rooms with 3 baths. Porcelain fixtures in the bathrooms, pneumatic-tube vacuums, seven-foot high mahogany wainscoting and ceiling beams in the dining room, and gas and electric lighting were among the features advertised.

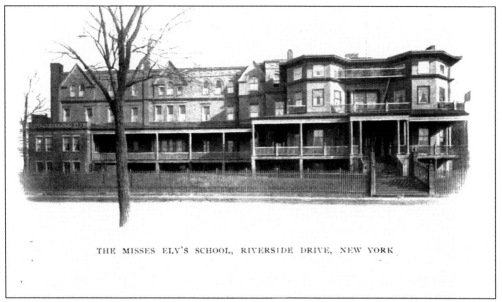

THE MISSES ELY'S SCHOOL, RIVERSIDE DRIVE, NEW YORK

The Misses Ely—Elizabeth, Sara, and Mary—were missionaries who started a finishing school for daughters of Brooklyn's fashionable elite in 1887. By 1900, they had relocated to Riverside Drive between West 85th and West 86th Streets. When encroached upon by apartment buildings and changing demographics, they moved up to Greenwich, Connecticut, in 1906. (Collection of Bob Stonehill.)

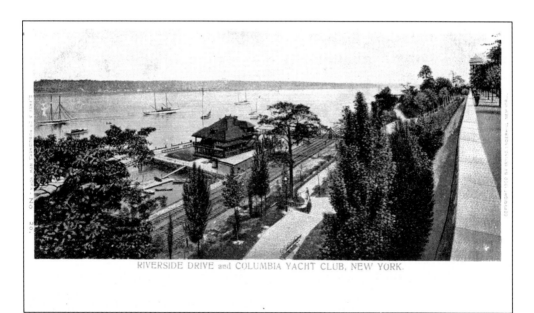

RIVERSIDE DRIVE and COLUMBIA YACHT CLUB, NEW YORK.

In the late 19th and early 20th centuries, yachting was a popular summertime amusement, and the Hudson River, although not as hospitable to racing as the Harlem River or Long Island Sound, had its share of adherents. At the foot of West 86th Street was the Columbia Yacht Club, which was organized in 1867 and presumably not affiliated with the university, which would not move up to Morningside Heights for another 28 years.

ISAAC LEOPOLD RICE, LL.B.

Isaac Leopold Rice (1850–1915), lawyer, industrialist, and chess master, was born in Germany and educated in Philadelphia, Paris, and New York. He litigated for the railroads, built U.S. Navy submarines and submarine chasers with his Electric Boat Company, and invented and promoted the Rice Gambit as president of the Manhattan Chess Club.

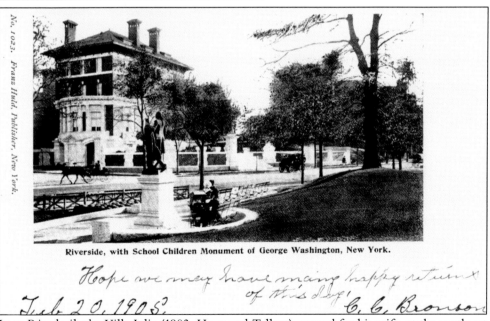

Riverside, with School Children Monument of George Washington, New York.

Hope we may have many happy returns of this day!

Feb 20, 1905.                    C. C. Bronson

Isaac Rice built the Villa Julia (1903, Herts and Tallant), named for his wife, at the southeast corner of West 89th Street. Julia, one of the first women to receive a medical degree, was staunchly antinoise, especially from river traffic, and founded the Society for the Suppression of Unnecessary Noise in 1905. The statue of George Washington across the street was erected in 1884, paid for with the nickels and dimes of schoolchildren.

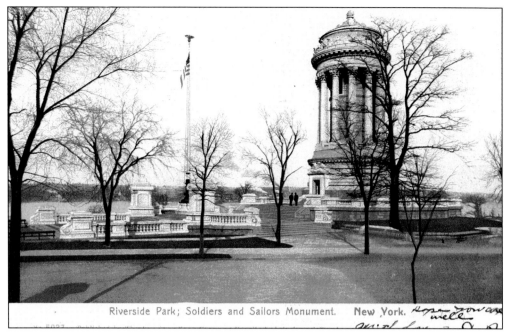

Riverside Park; Soldiers and Sailors Monument.   New York.

Dedicated "To the Memory of the Brave Soldiers and Sailors who Saved the Union" in the Civil War, the Soldiers and Sailors Monument (Stoughton and Stoughton with Paul E. M. Duboy) has stood on Riverside Drive at the foot of West 89th Street since 1902.

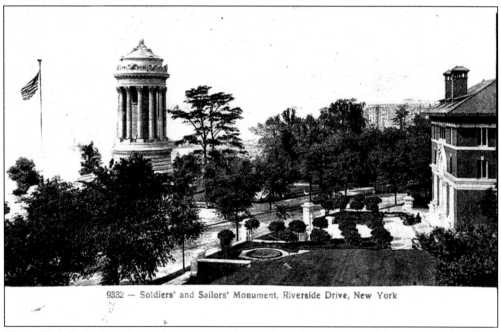

9332 — Soldiers' and Sailors' Monument, Riverside Drive, New York

The Villa Julia had landscaped grounds to the south and west prepared by Herts and Tallant. By 1923, the 15-story 160 Riverside Drive would replace the southern portion at the northeast corner of West 88th Street, but the Villa Julia and its unique front yard remain to this day as the Yeshiva Ketana of Manhattan. It is one of only two freestanding mansions remaining on the drive.

RT. REV. HENRY C. POTTER, D.D., LL.D.

Rt. Rev. Henry Codman Potter (1835–1908), Bishop of the Protestant Episcopal Diocese of New York from 1888, continued the work of his uncle Rt. Rev. Horatio Potter in establishing and building the Cathedral Church of St. John the Divine on Morningside Heights in the 1890s. In 1902, at the age of 67, he married Elizabeth Scriven Clark, widowed from the Singer Sewing Machine Company heir Alfred Corning Clark in 1896.

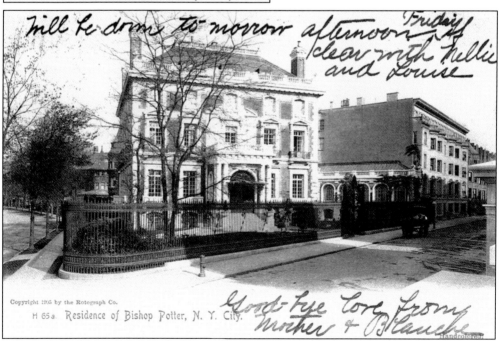

Copyright 1905 by the Rotograph Co.
H 65a. Residence of Bishop Potter, N. Y. City.

Elizabeth Scriven Clark built a residence on the northeast corner of West 89th Street in 1900 with the front facade oriented southwest over the Hudson River and Riverside Park. Designed by Ernest Flagg, it had a conservatory and bowling alley in the wing attached at right. The town houses at right are still extant.

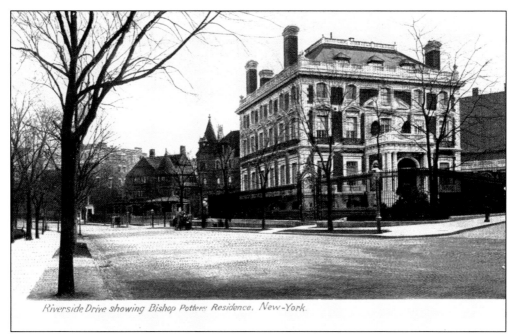

This magnificent view of Riverside Drive from West 89th to West 91st Street shows a lost world of private residences. The Elizabeth Scriven Clark house, also known as Bishop Potter's residence, is in the foreground. Behind it is the Cyrus Clark house, and in the distance is the John Mathews house. By the mid-1920s, these homes would be razed for a solid wall of apartment houses, spreading up and down the thoroughfare since 1908.

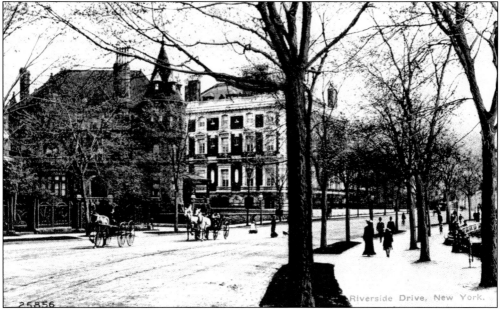

Cyrus Clark, "Father of the West Side," built this house on the southeast corner of West 90th Street in 1889. Designed by Henry F. Kilburn, it was one of the first freestanding houses on the drive. In 1926, 173–175 Riverside Drive (J. E. R. Carpenter) was built on the entire blockfront where both Clark homes once stood.

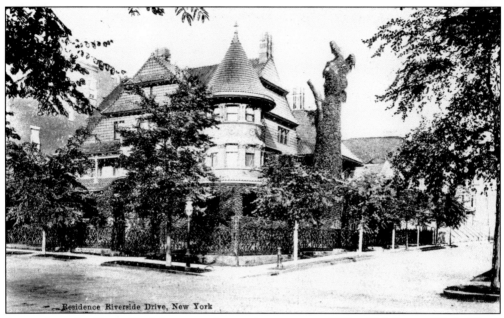

Across from the Cyrus Clark house on the northeast corner of West 90th Street, "Soda-Water King" John Mathews built an elaborate picturesque cottage designed by Lamb and Rich in 1892. Although made of stone, brick, and terra-cotta, the house and its setting, overgrown with vines and trees, harkens back to a more rustic time. The house was razed in 1921 for 180 Riverside Drive (Schwartz and Gross).

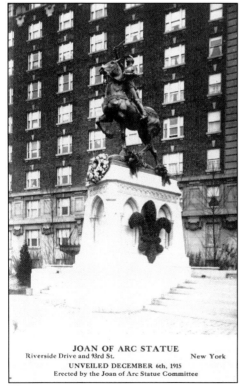

**JOAN OF ARC STATUE**
Riverside Drive and 93rd St.      New York
UNVEILED DECEMBER 6th, 1915
Erected by the Joan of Arc Statue Committee

The statue of Joan of Arc, French martyr and saint, was installed in Riverside Park at West 93rd Street in 1915. Commissioned in 1909, it was created by art patron and sculptor Anna Hyatt Huntington. The foundation contains stones from the tower in Rouen where Joan of Arc was imprisoned before her death. Behind the statue is the Stratford-Avon apartment house (1910, Schwartz and Gross).

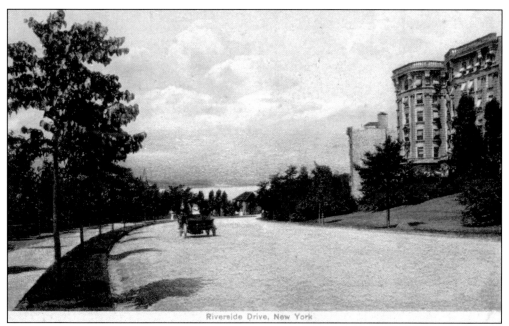

Riverside Drive, New York

As Riverside Drive begins an almost 30-foot downhill curve to West 96th Street, it splits into a lower drive and an upper one. The upper roadway is a service road for the apartment houses and meant to separate them from the traffic below. The Chatillion (Stein, Cohen and Roth), a modest seven-story apartment house, has stood at the southeast corner of West 94th Street since 1902.

THE ROBERT FULTON, THE HUDSON, NEW YORK CITY

*1727 Critger Ave Van Nest N y*

Looking south along Riverside Drive from West 96th Street, the first wave of apartment house building is evident in this early-20th-century view. The Hudson (1898, John Woolley) on the southeast corner of West 95th Street is still extant, while the Robert Fulton succumbed to development pressure in 1931 with the 20-story House of Individual Charm, 230 Riverside Drive.

121

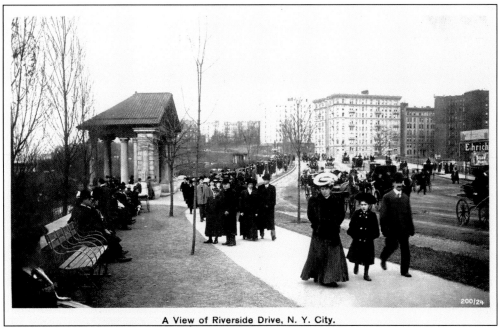

A View of Riverside Drive, N. Y. City.

This view of a Sunday stroll in 1905 was taken several years after the construction of the viaduct over West 96th Street but before the erection of the iconic Cliff Dwelling (1913, Herman Lee Meader) with its terra-cotta skulls. The Riverside Park shelter opposite West 95th Street (left) was one of a pair; the other was at West 97th Street. This shelter is now the site of the off-ramp from the Henry Hudson Parkway at West 95th Street.

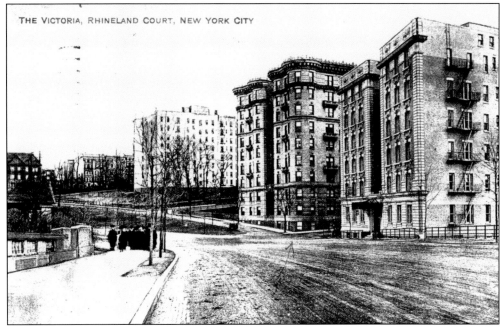

THE VICTORIA, RHINELAND COURT, NEW YORK CITY

Rhineland Court was built in 1907 at the southeast corner of West 97th Street several years after the early-20th-century Victoria apartments across the street. Both are still extant. The empty lots to the north on the drive were not left vacant for long (page 123).

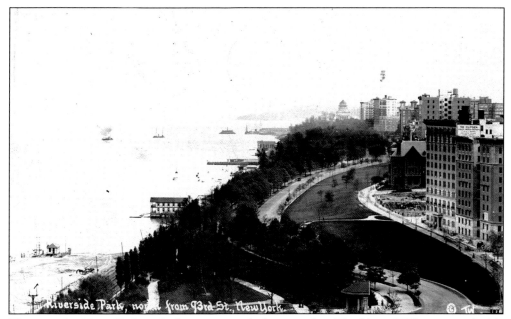

The premier New York real-photo postcard photographer Thaddeus Wilkerson took this photograph from an apartment house on West 93rd Street looking north over Riverside Drive and the Hudson River in 1911. The Chesterfield apartment house was nearing completion at the northeast corner of West 98th Street, and the Clifden at the southeast corner of West 99th Street was only a year old. Peter Doelger's mansion lay just beyond these at West 100th Street.

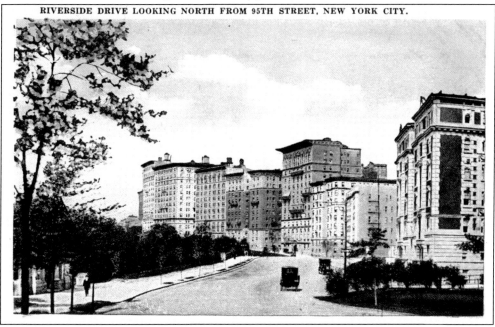

By 1911, there was a virtually solid wall of apartment houses along Riverside Drive from West 95th northward. From right to left, these included the Robert Fulton, Rhineland Court, Victoria, Peter Stuyvesant, Chesterfield, Clifden, Glencairn, and Gwendolyn. All except the Robert Fulton are still extant.

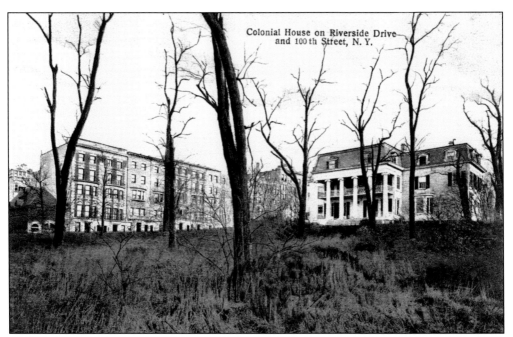

Colonial House on Riverside Drive and 100th Street, N. Y.

Built as a country estate in the early 1800s by William P. Furniss, this roomy mansion with pillared portico, referred to as the "Old Colonial White House," occupied the block bounded by Riverside Drive and West End Avenue from West 99th to West 100th Streets. It was razed in 1910 to make way for the 12-story Wendolyn apartment house. (Collection of Bob Stonehill.)

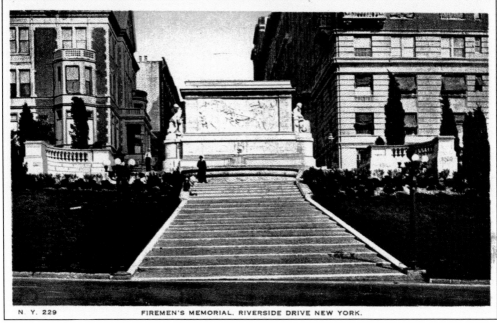

N. Y. 229          FIREMEN'S MEMORIAL. RIVERSIDE DRIVE NEW YORK.

The Wendolyn is the building to the right of the Firemen's Memorial in this 1915 view looking east toward upper Riverside Drive from the lower drive; to the left is the Peter Doelger mansion. The idea of Bishop Henry Codman Potter, the memorial, designed by H. Van Buren Magonigle, was dedicated in 1913 "To the Heroic Dead of the Fire Department."

Peter Doelger (1832–1912), immigrant from Bavaria, began a brewery in 1859 on the east side of Manhattan, which grew into one of the largest in the United States by 1895. The business was moved to New Jersey by his son Peter in the 1920s to the former Peter Hauck Brewery and by 1947 was defunct.

PETER DOELGER, SEN.

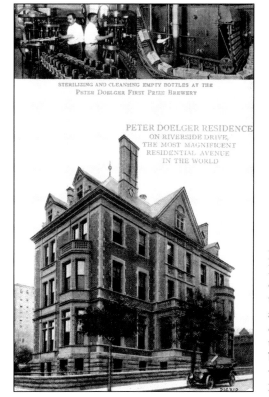

STERILIZING AND CLEANSING EMPTY BOTTLES AT THE
PETER DOELGER FIRST PRIZE BREWERY

PETER DOELGER RESIDENCE
ON RIVERSIDE DRIVE,
THE MOST MAGNIFICENT
RESIDENTIAL AVENUE
IN THE WORLD

Doelger resided at the northeast corner of Riverside Drive at West 100th Street in this comfortable residence from 1885. Adjoining the home was the famous Doelger chapel and in the backyard, a carriage house, which can be seen to the far left in the view of the Furniss house on the prior page. After being sold for $900,000 in 1925, the house was razed and replaced with the 15-story 280 Riverside Drive (Rosario Candela).

125

The dignified Clearfield (1910, Lawlor and Haase), on the southeast corner of West 103rd Street, boasted large, light, and airy rooms. Its neighbor to the south on the southeast corner of West 102nd Street is 299 Riverside Drive (1910, Evan T. McDonald). Between these apartment houses is the Foster mansion, a three-story brick residence set back from the drive on a high terrace. By 1922, the mansion was razed for the 15-story 300 Riverside Drive (George F. Pelham).

The Clearfield, 324 West 103D St., New York.

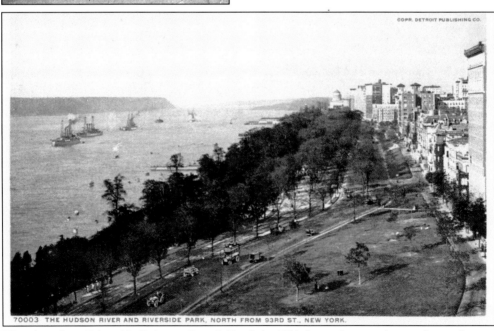

70003 THE HUDSON RIVER AND RIVERSIDE PARK, NORTH FROM 93RD ST., NEW YORK.

The view along Riverside Drive to Grant's Tomb in 1911 shows the mansions and town houses to the north of the Clearfield (far right). Many of these, from West 103rd to West 108th Streets, would soon be lost to development. Remaining among them are the Schinasi mansion (1909, William Tuthill) at West 107th Street and the sumptuous town houses in the Riverside–West 105th Street Historic District.

# BIBLIOGRAPHY

Birmingham, Stephen. *Life at the Dakota: New York's Most Unusual Address.* New York: Random House, 1979.

Dunlap, David W. *On Broadway: A Journey Uptown Over Time.* New York: Rizzoli, 1990.

——. *From Abyssinian to Zion: A Guide to Manhattan's Houses of Worship.* New York: Columbia University Press, 2004.

Gray, Christopher. *New York Streetscapes: Tales of Manhattan's Significant Buildings and Landmarks.* New York: Harry Abrams Inc. Publishers, 2003.

King, Moses. *Notable New Yorkers of 1896–1899: A Companion Volume to King's Handbook of New York City.* New York and Boston: Moses King, 1899.

Salwen, Peter. *Upper West Side Story: A History and Guide.* New York: Abbeville Press, 1989.

Stern, Robert A.M., Gregory Gilmartin, and John Montague Massengale. *New York 1900: Metropolitan Architecture and Urbanism 1890–1915.* New York: Rizzoli, 1983.

Sypher, Francis J., Jr. *St. Agnes Chapel of the Parish of Trinity Church in the City of New York 1892–1943.* New York: Parish of Trinity Church in the City of New York, 2002.

# DISCOVER THOUSANDS OF LOCAL HISTORY BOOKS FEATURING MILLIONS OF VINTAGE IMAGES

Arcadia Publishing, the leading local history publisher in the United States, is committed to making history accessible and meaningful through publishing books that celebrate and preserve the heritage of America's people and places.

## Find more books like this at
## www.arcadiapublishing.com

Search for your hometown history, your old stomping grounds, and even your favorite sports team.